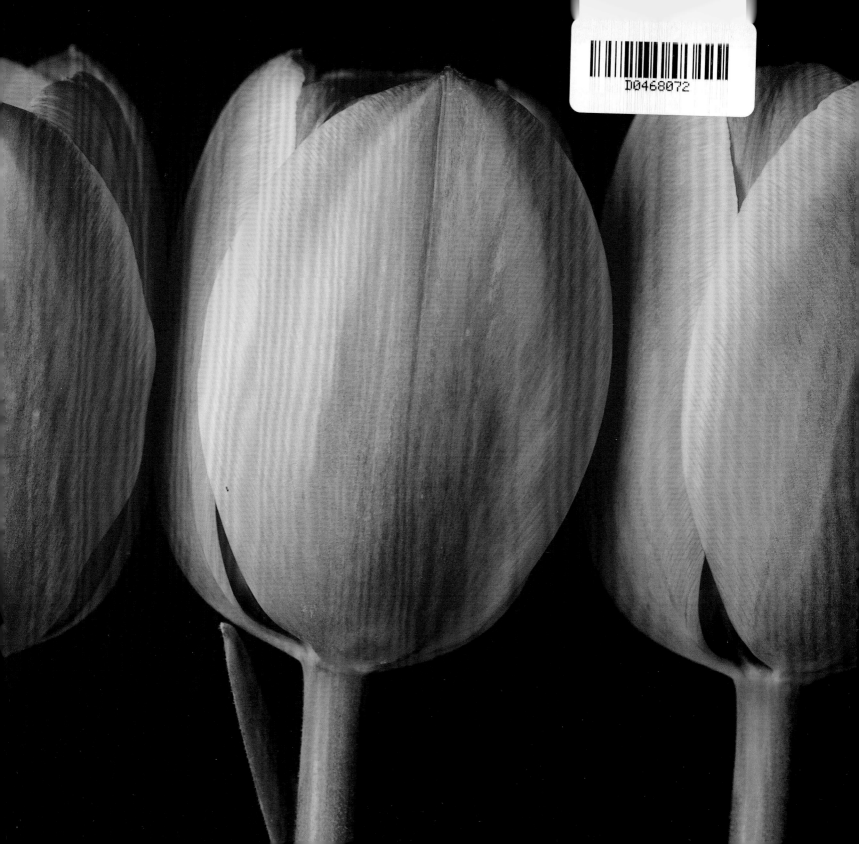

Be Gentle with the Young

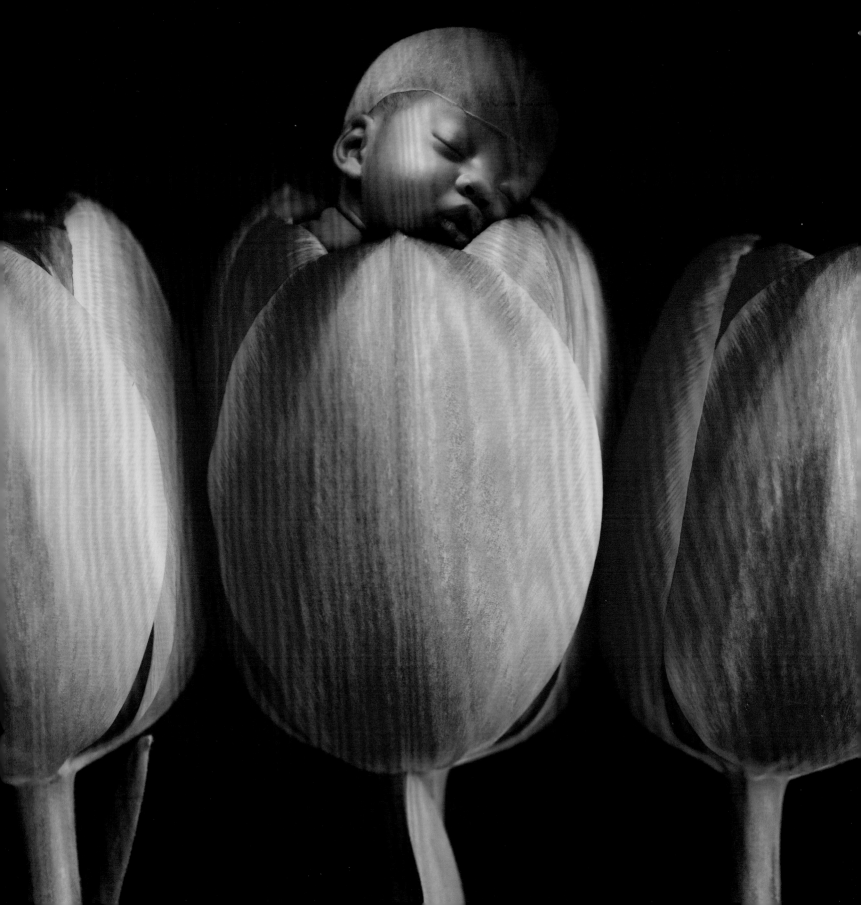

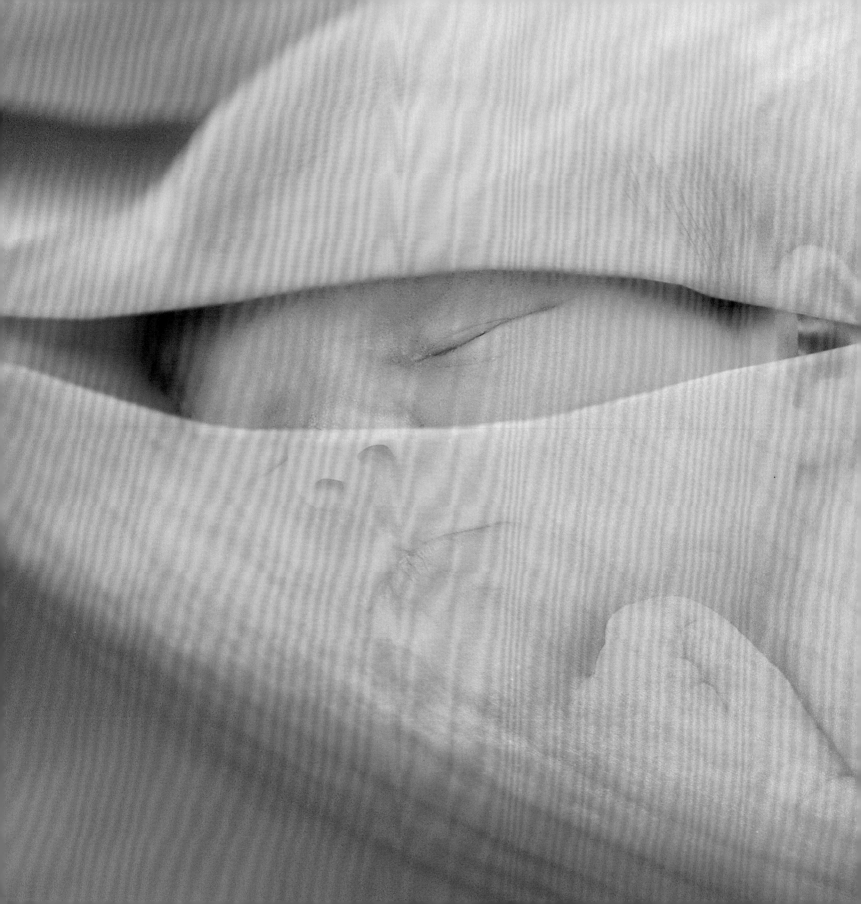

ANNE GEDDES

Be Gentle with the Young

Andrews McMeel
Publishing, LLC

Kansas City

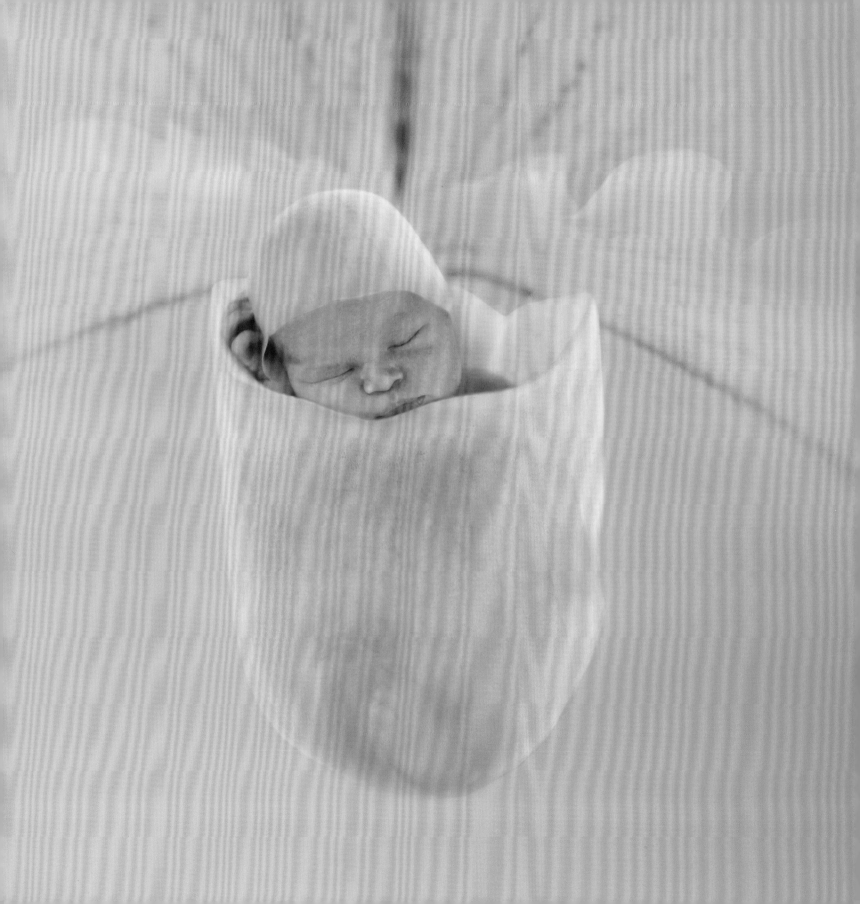

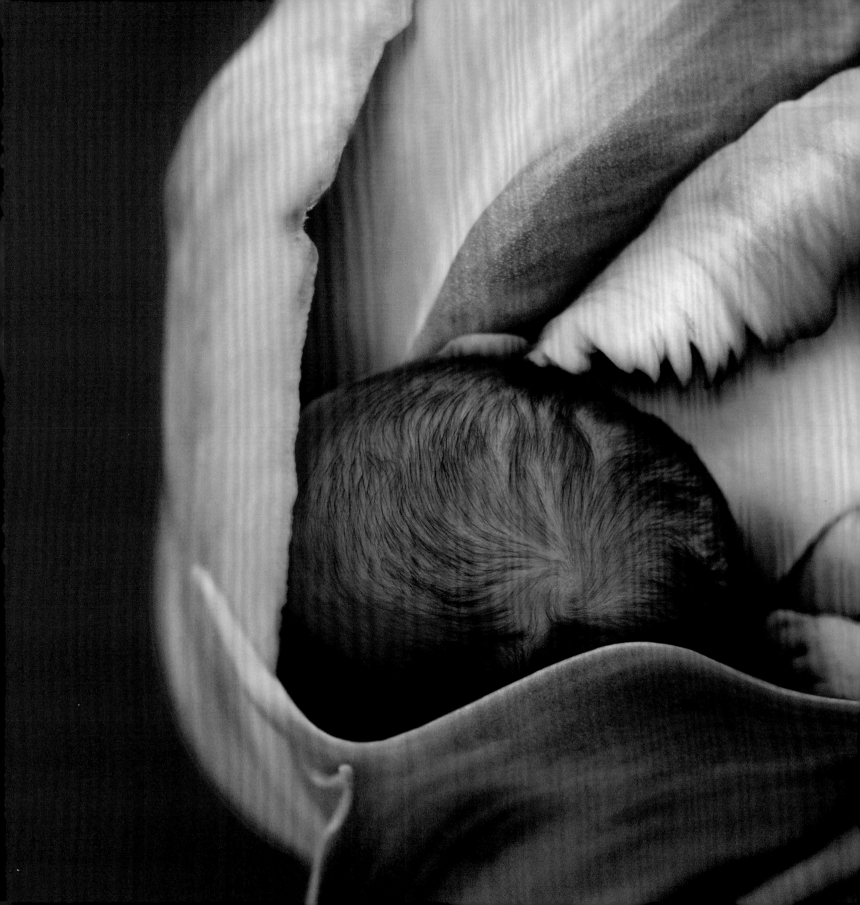

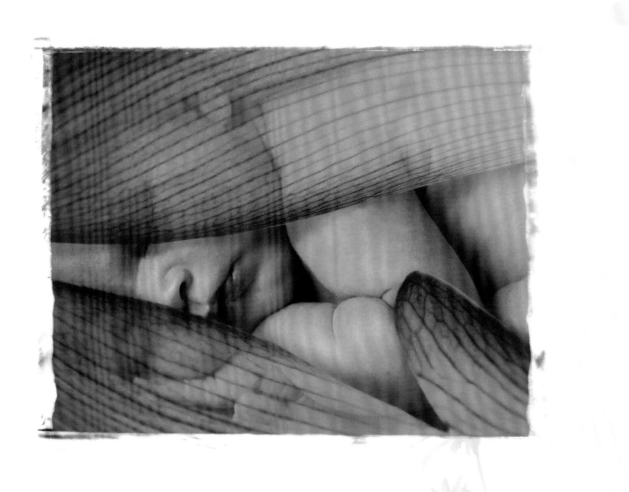

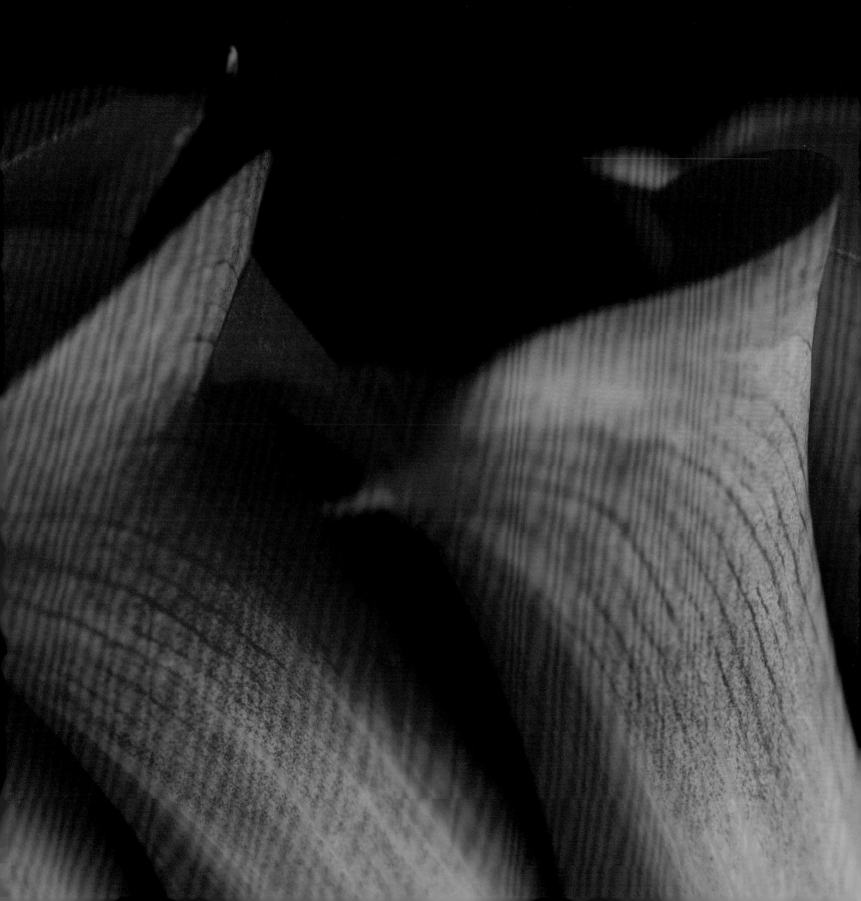

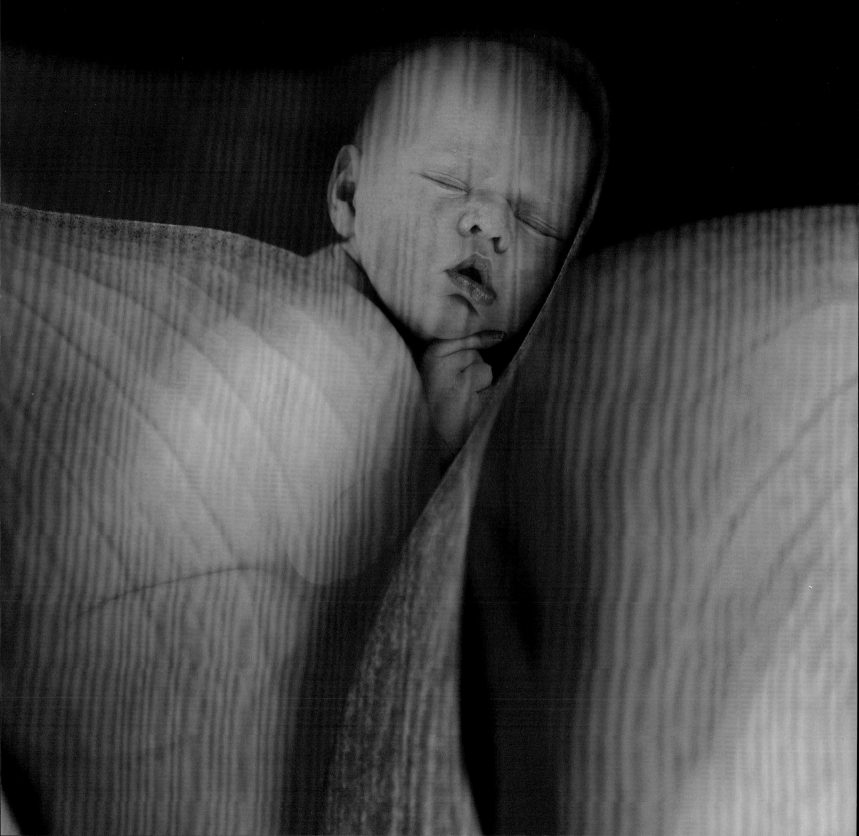

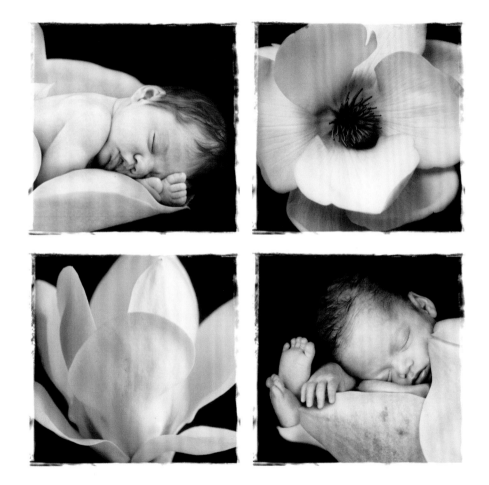

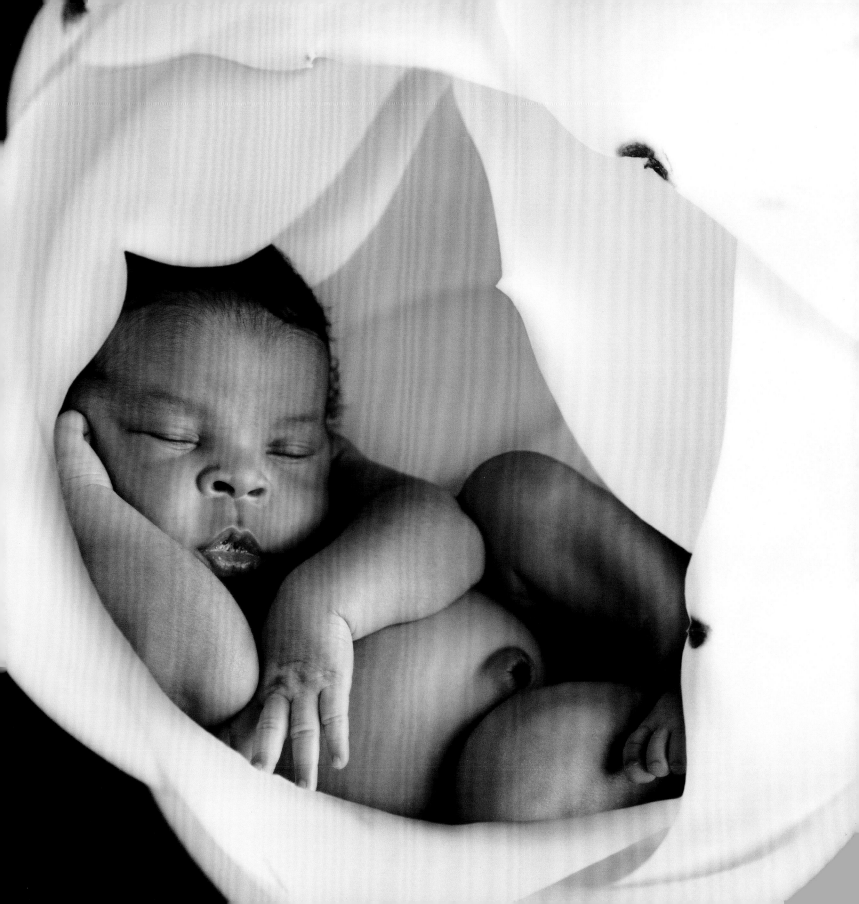

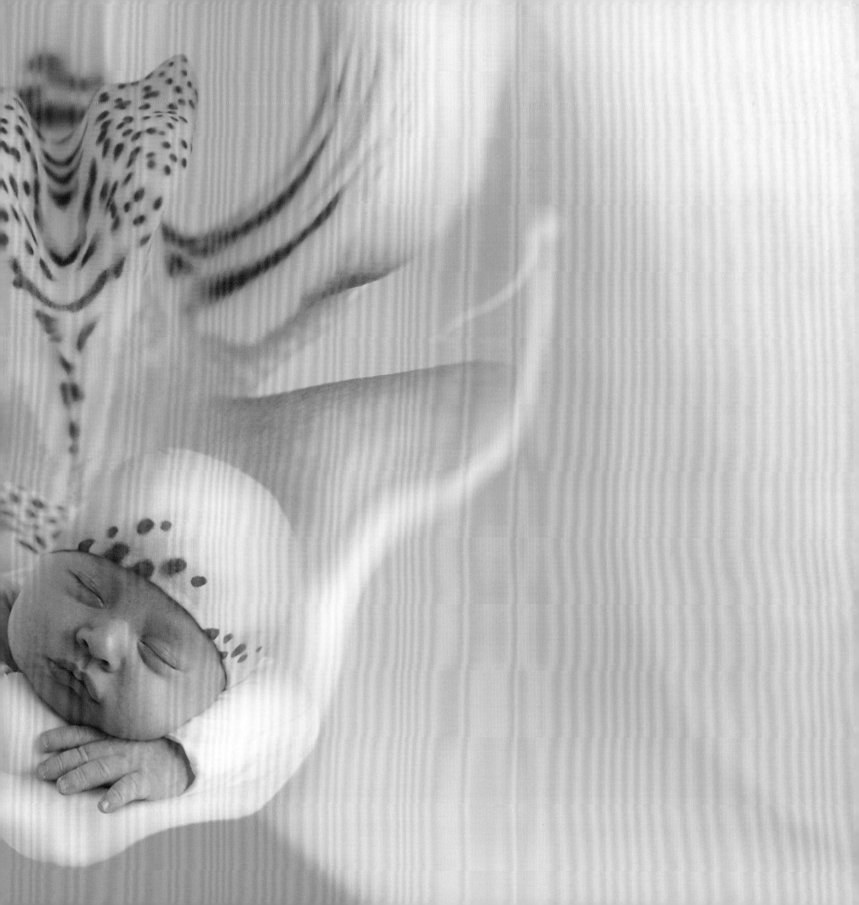

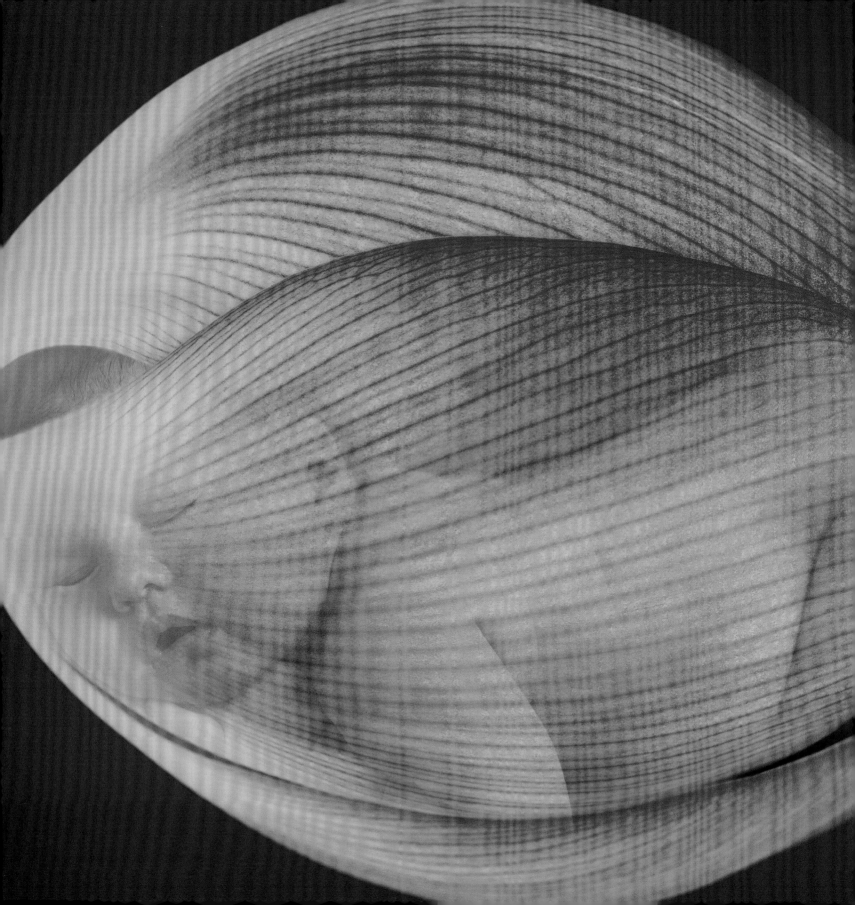

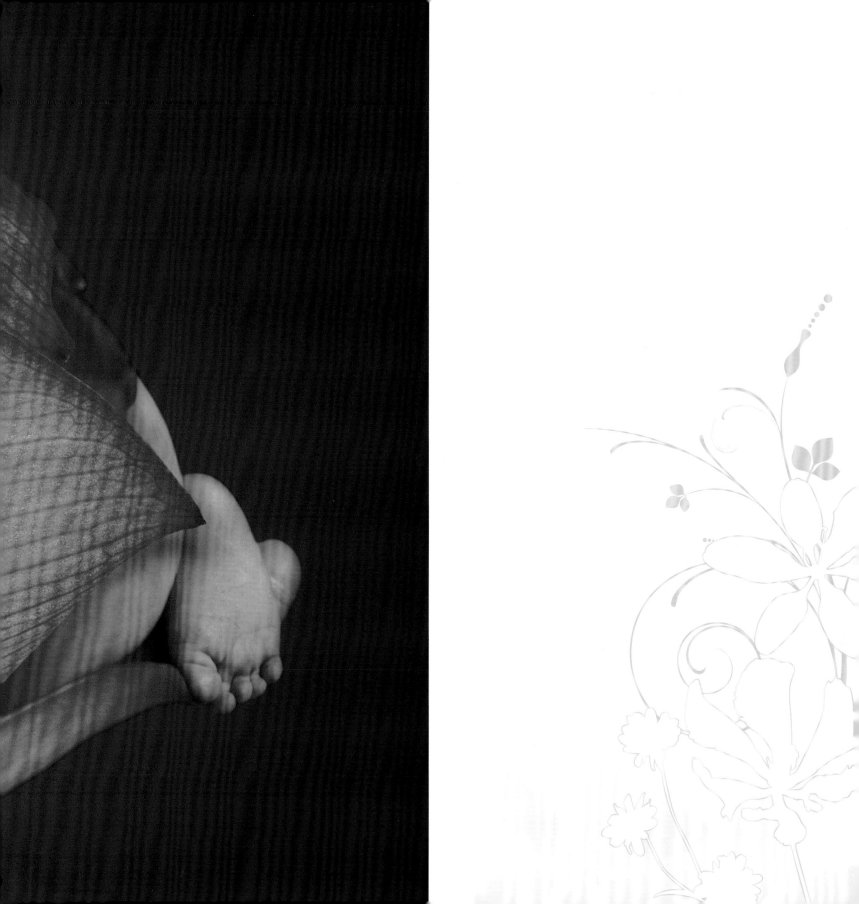

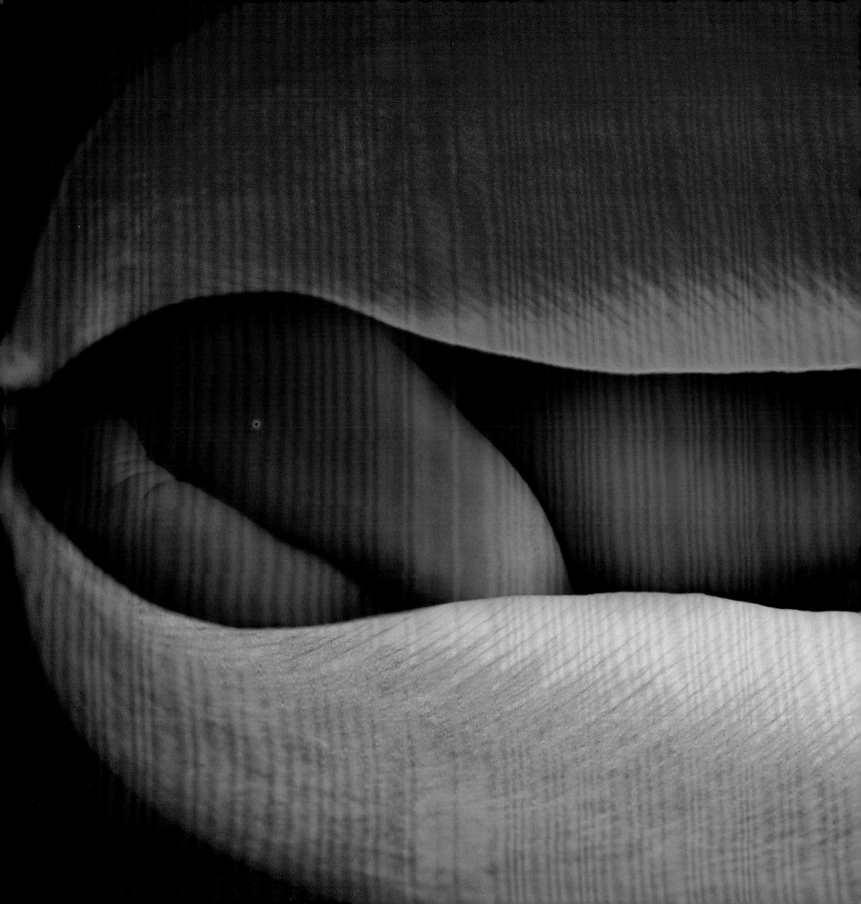

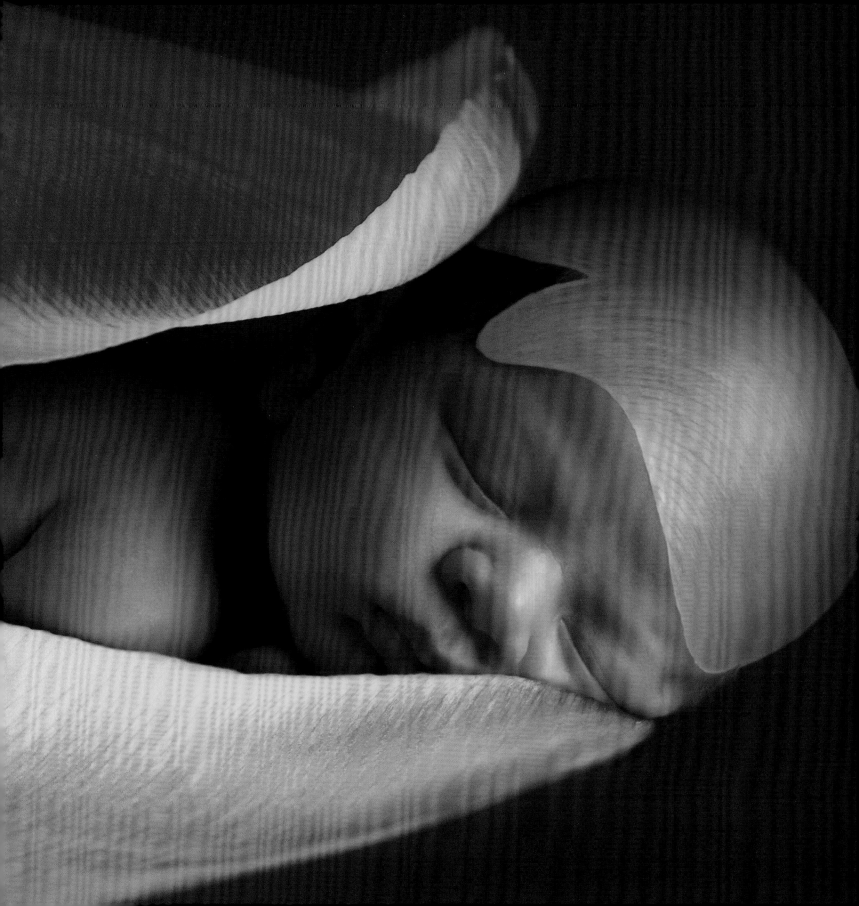

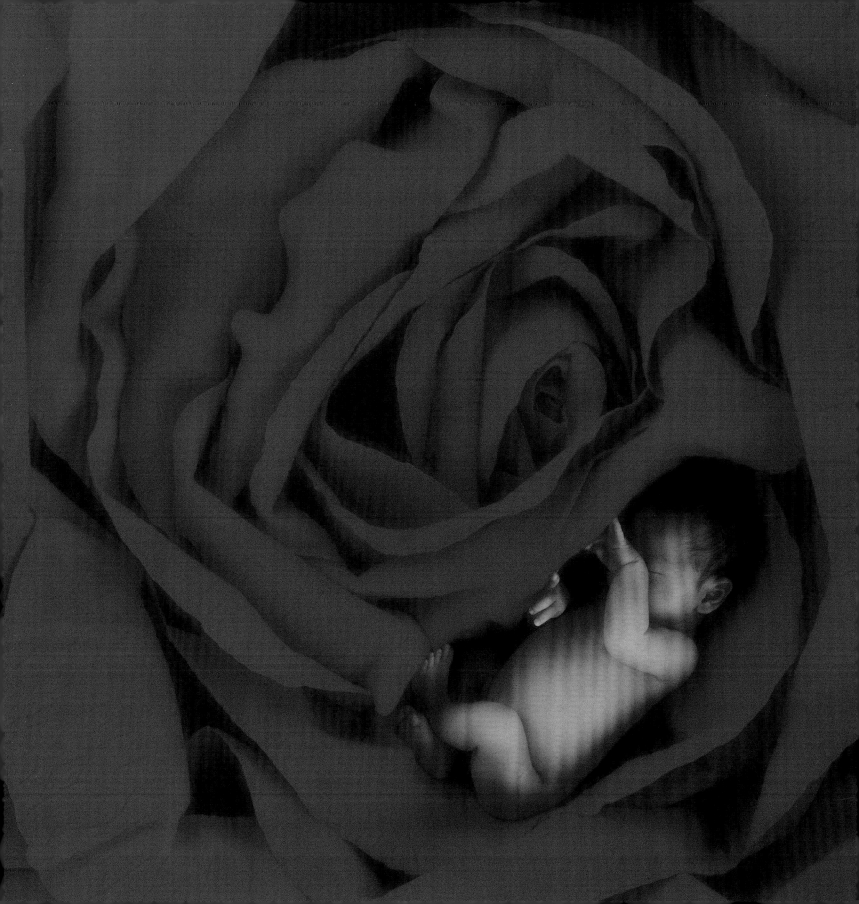

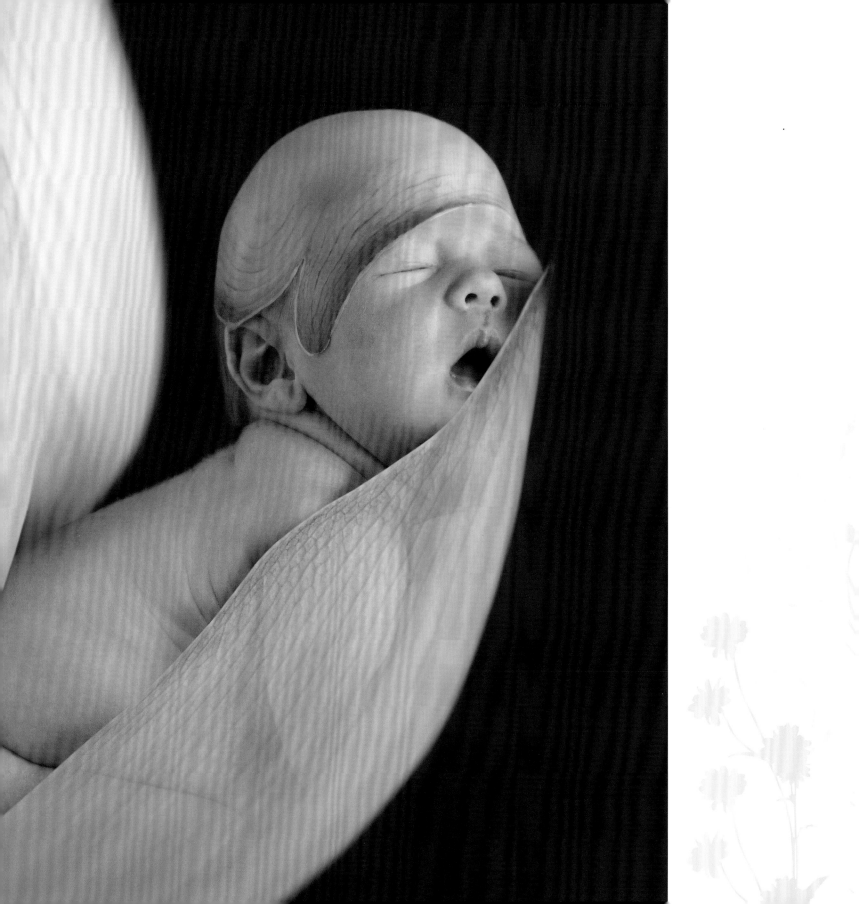

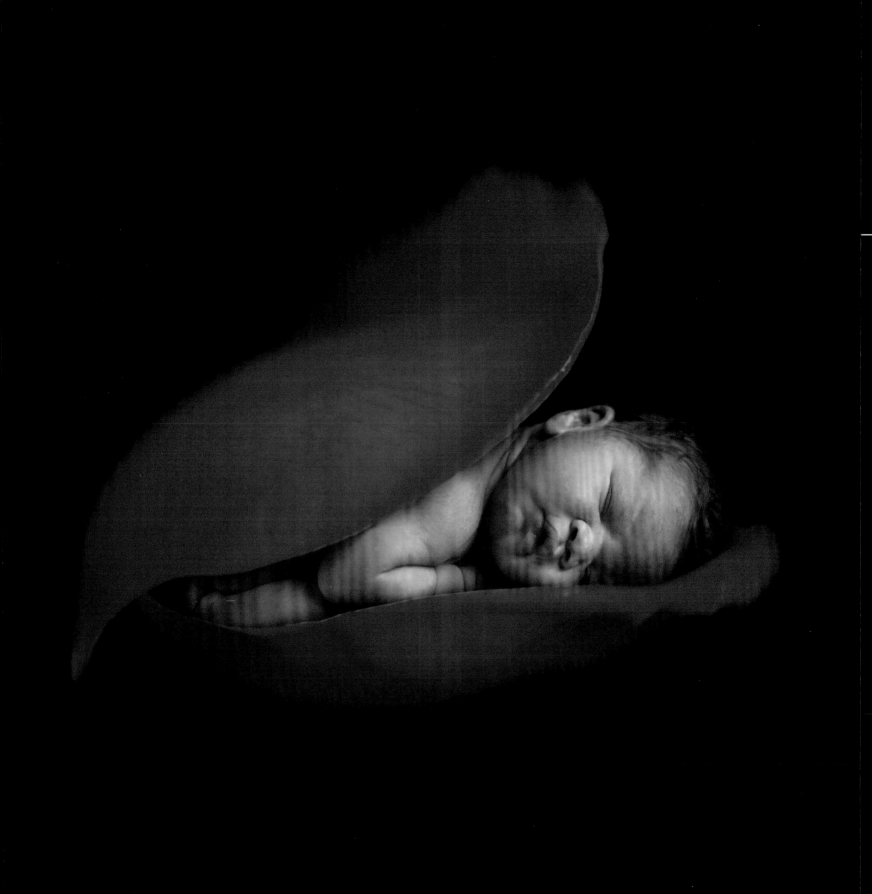

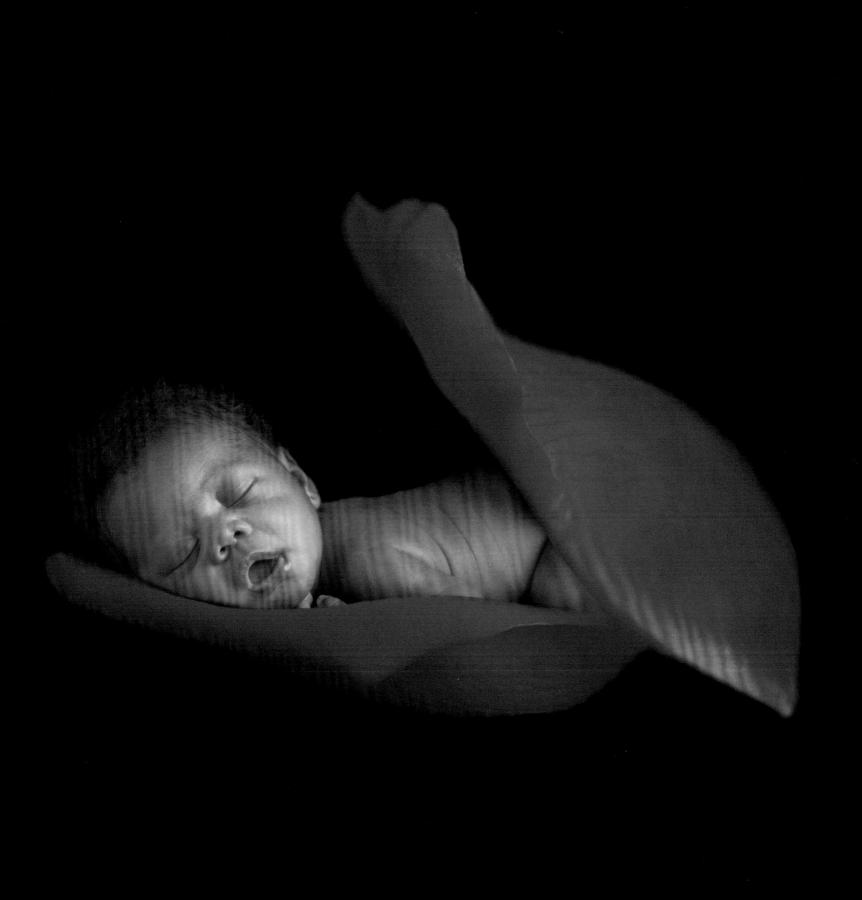

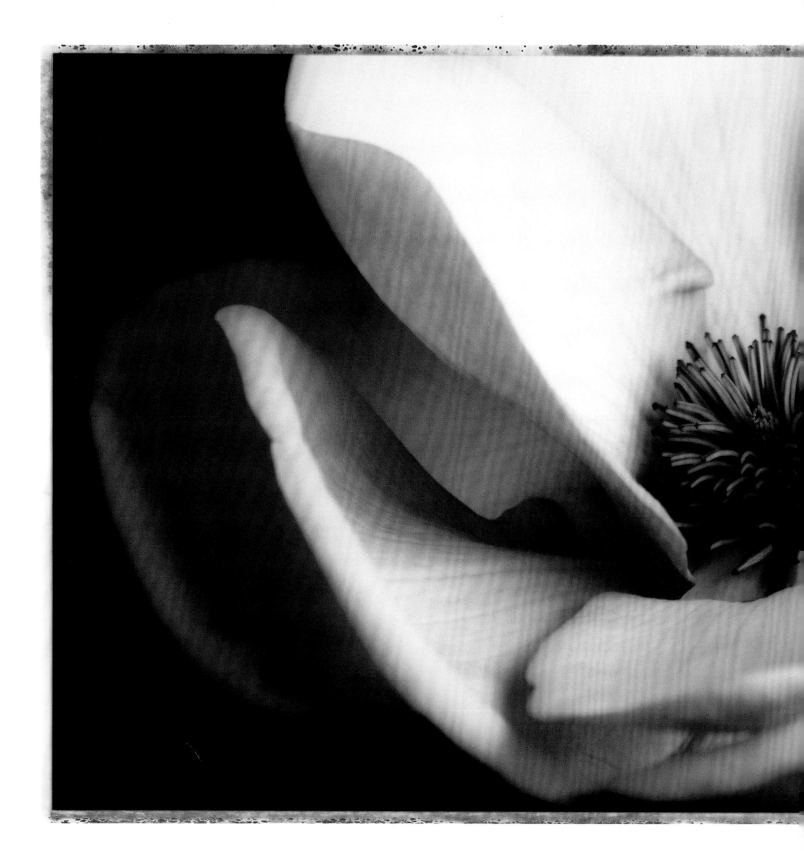

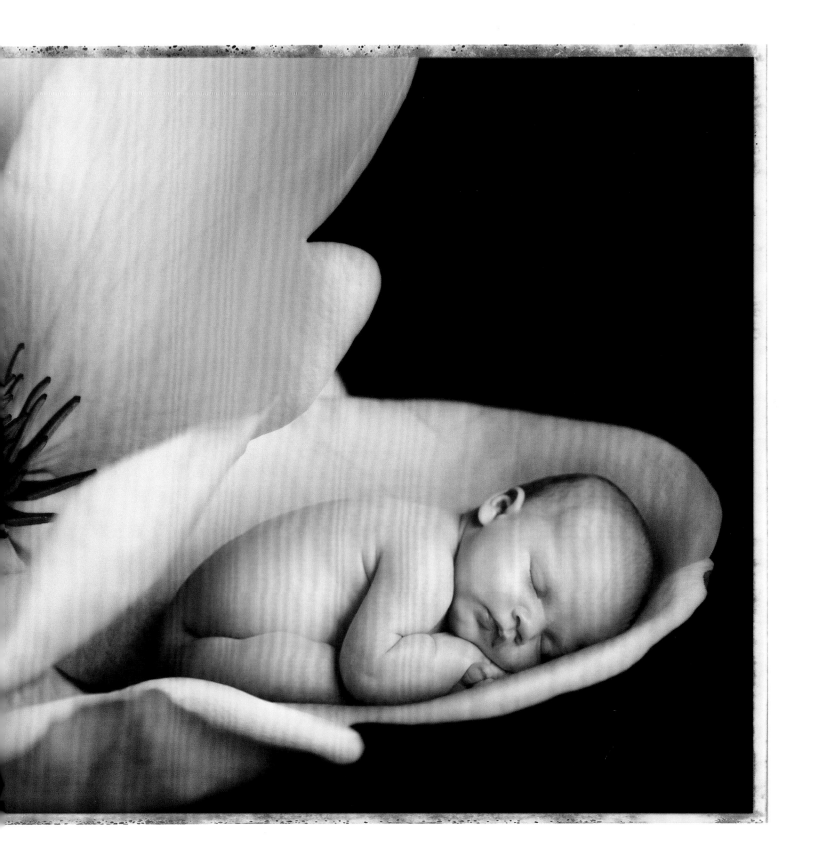

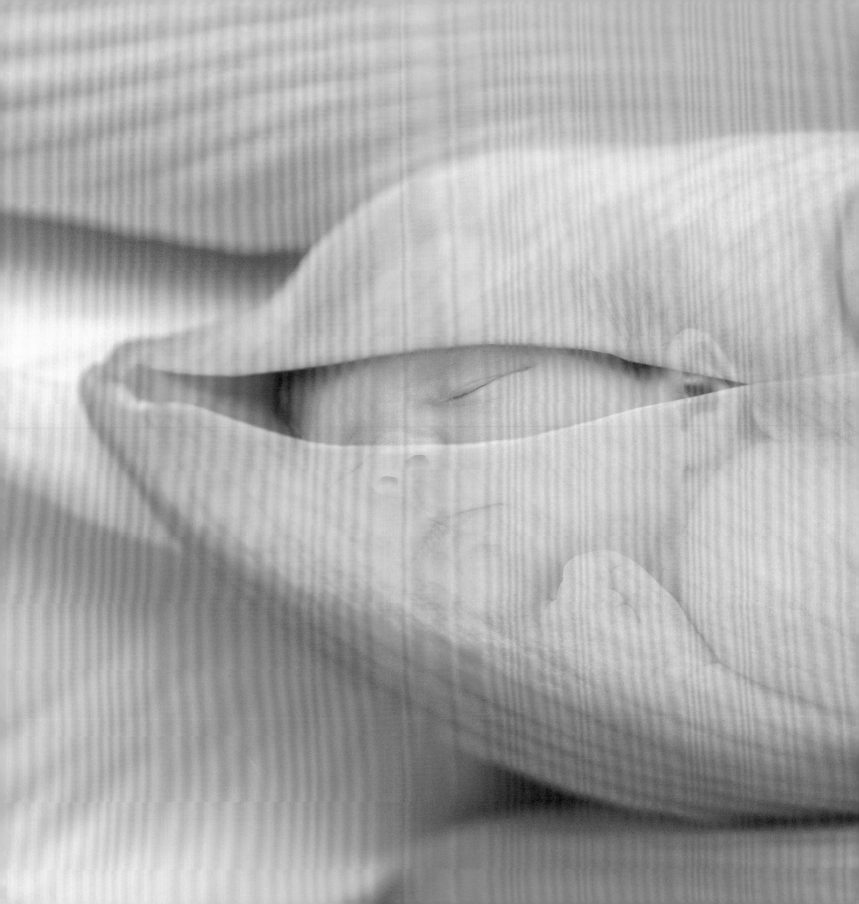

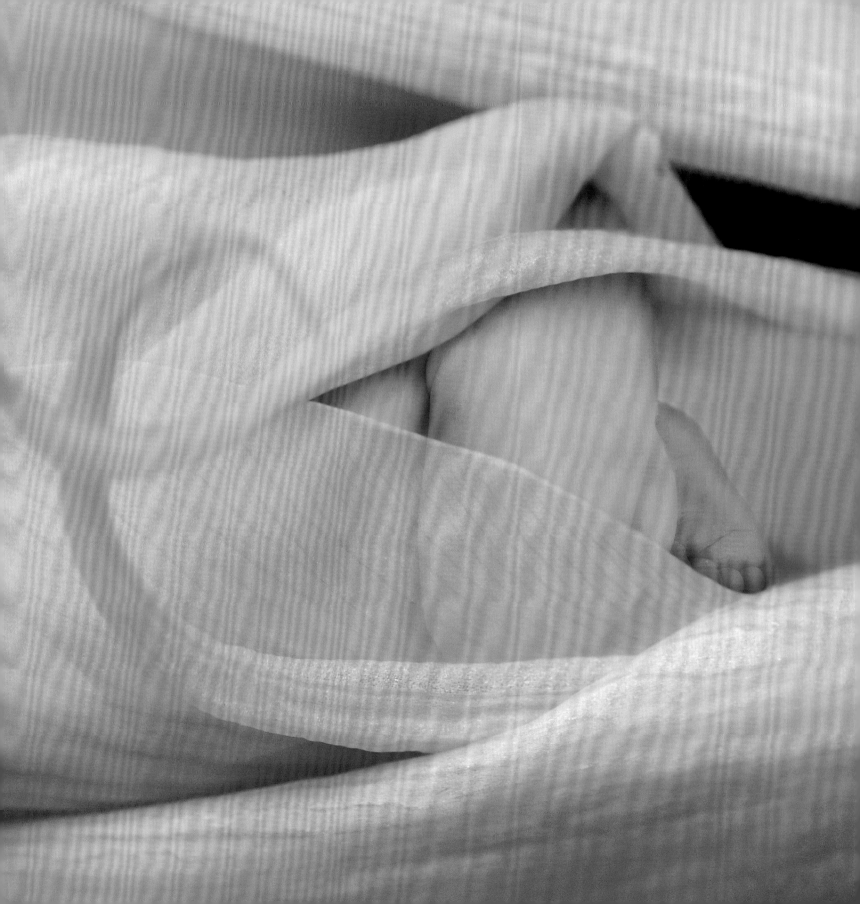

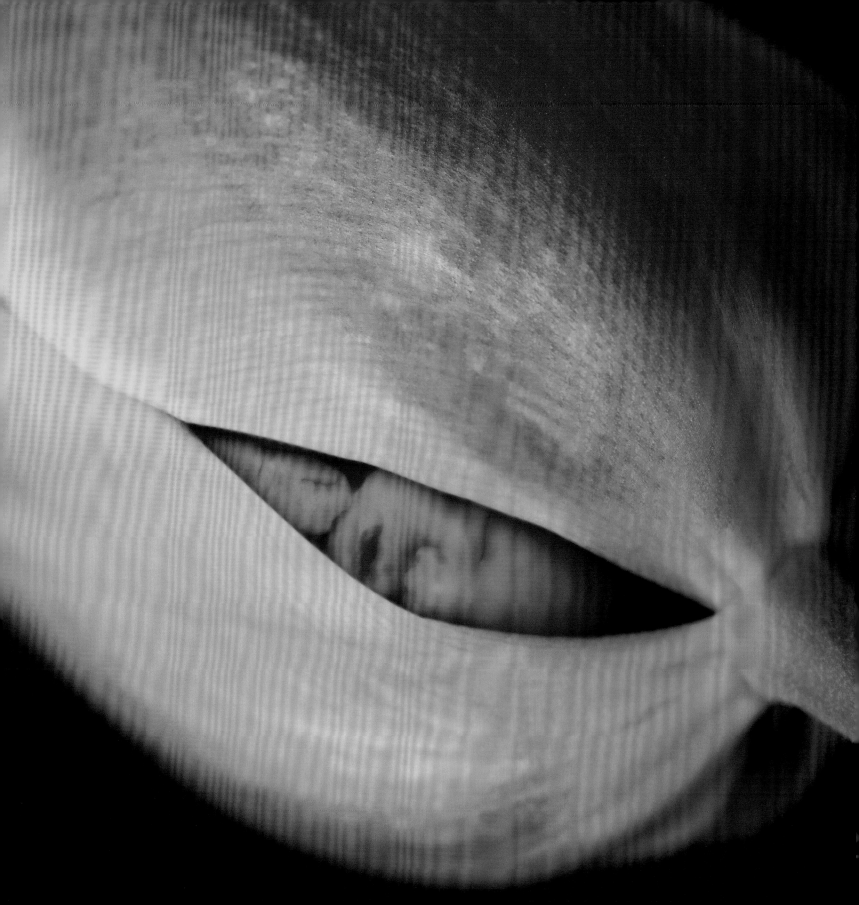

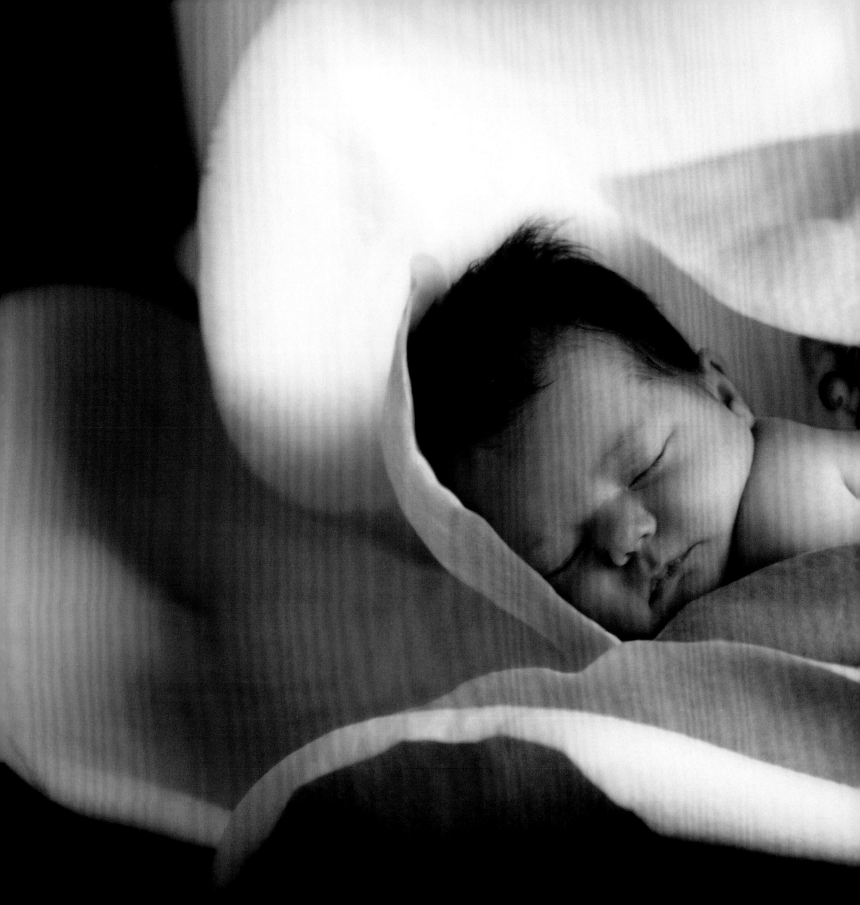

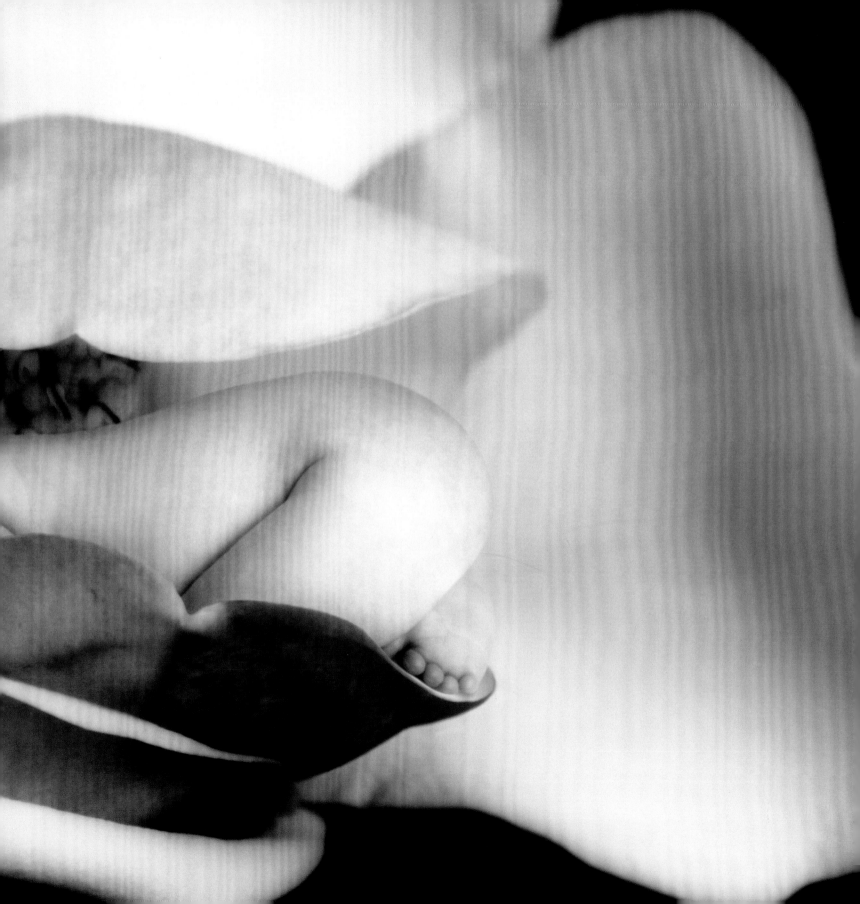

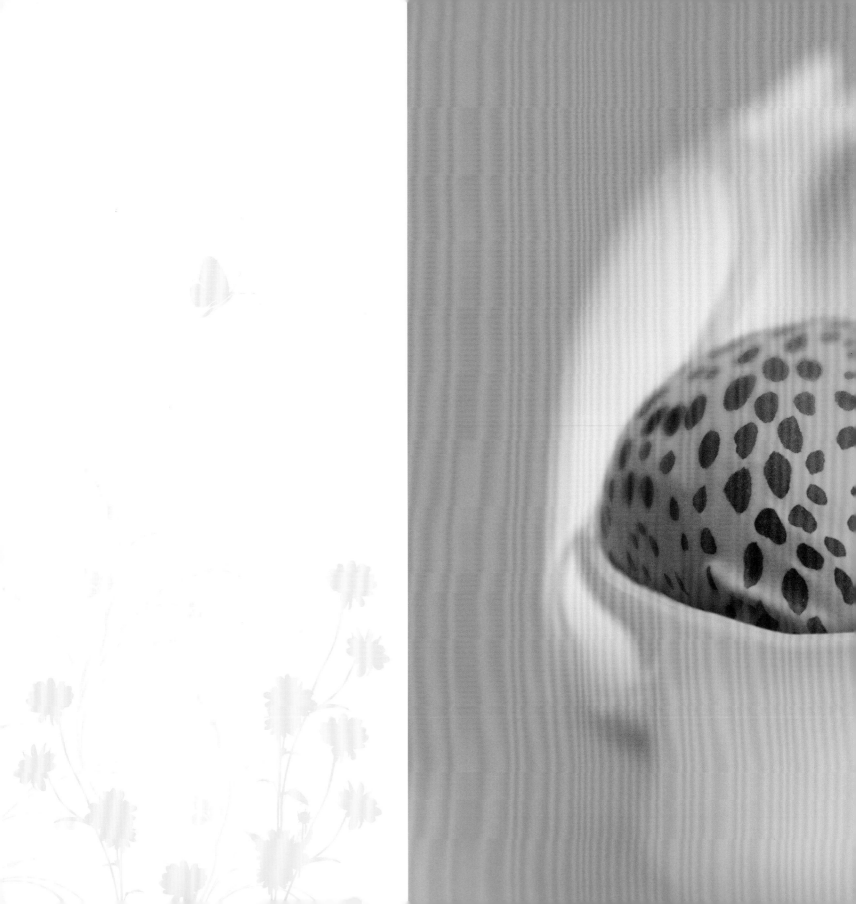

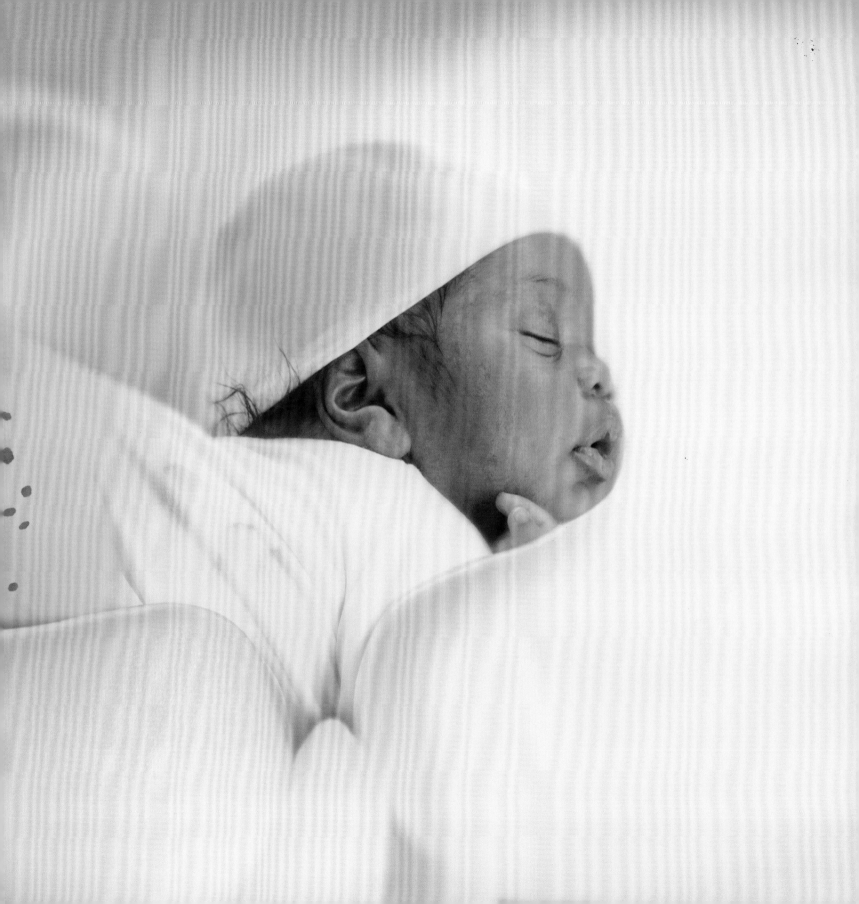

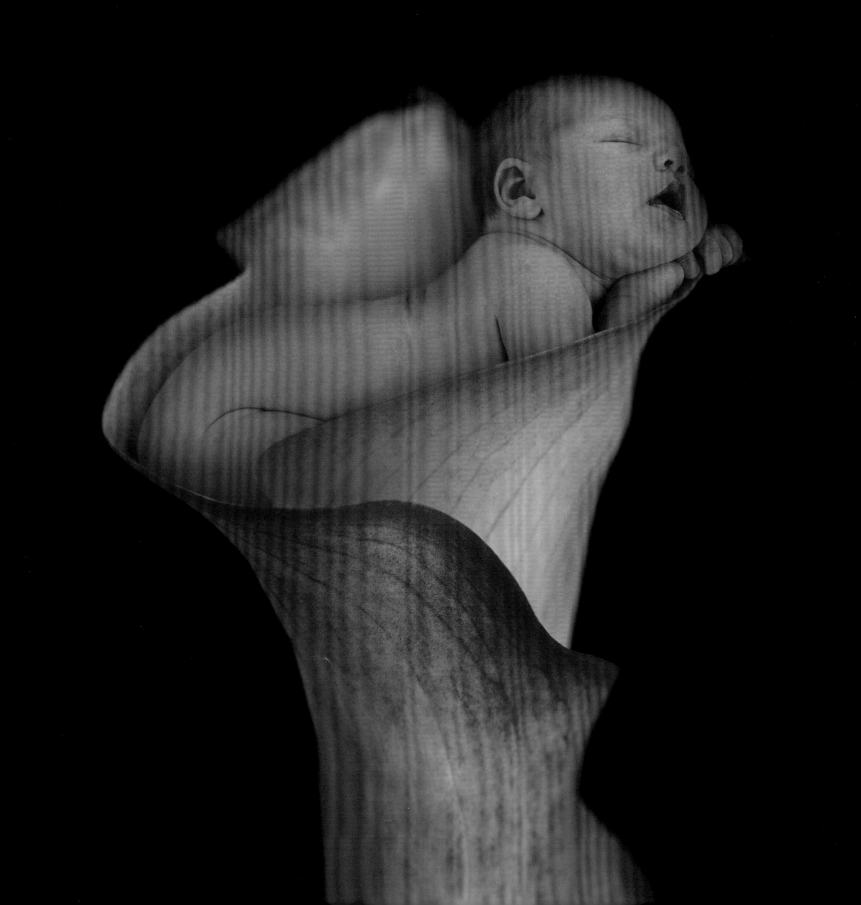

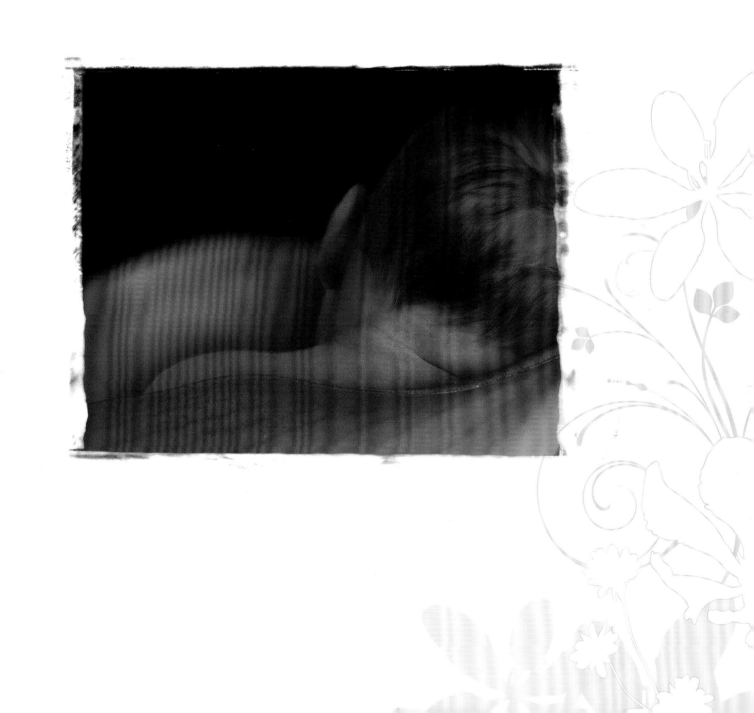

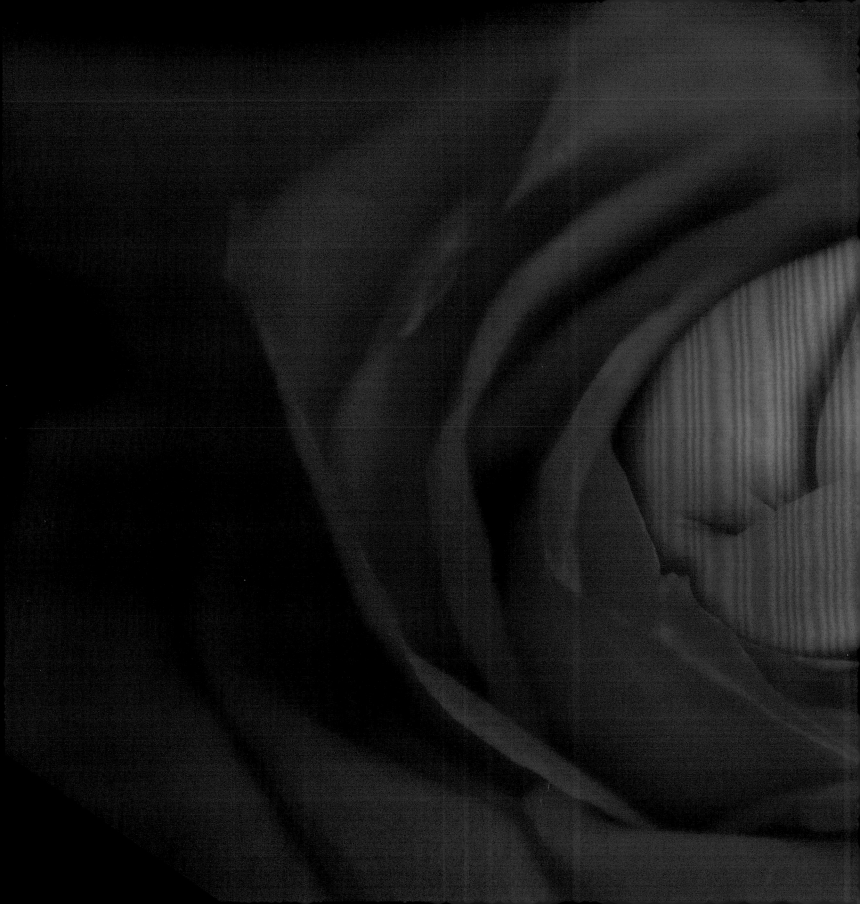

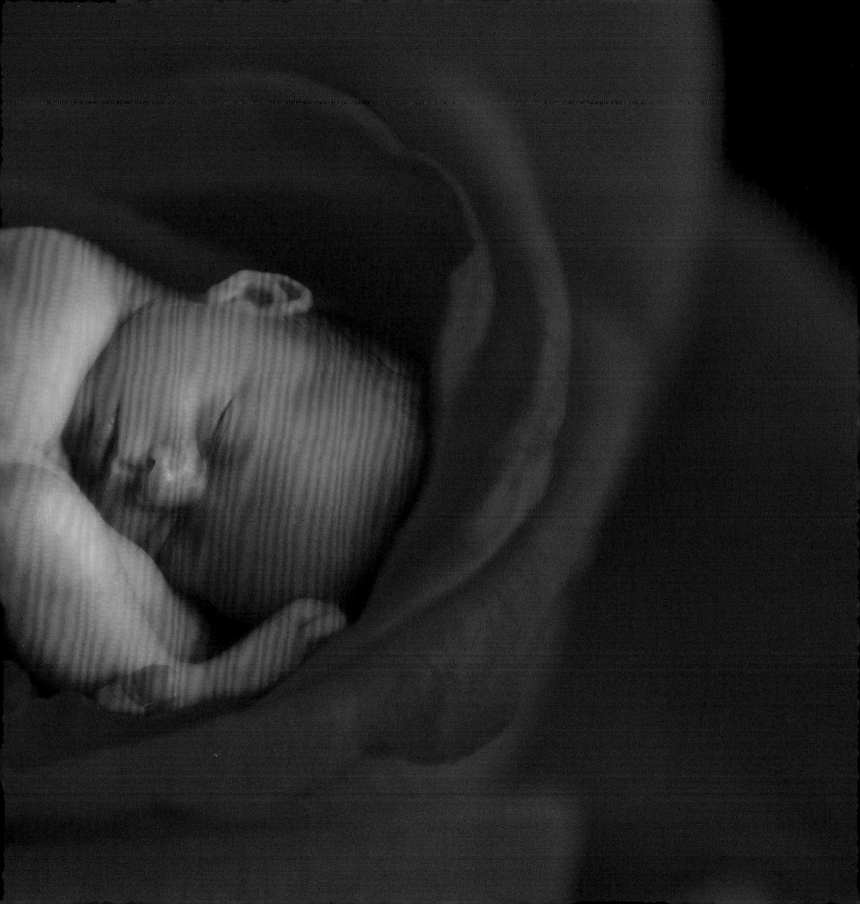

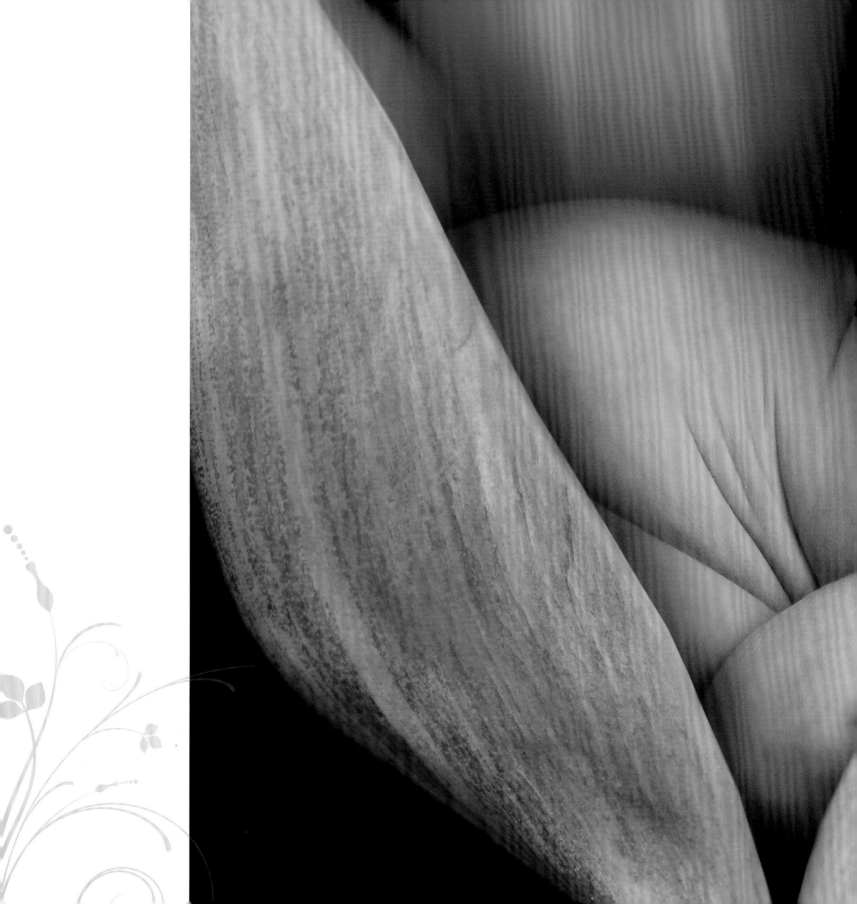

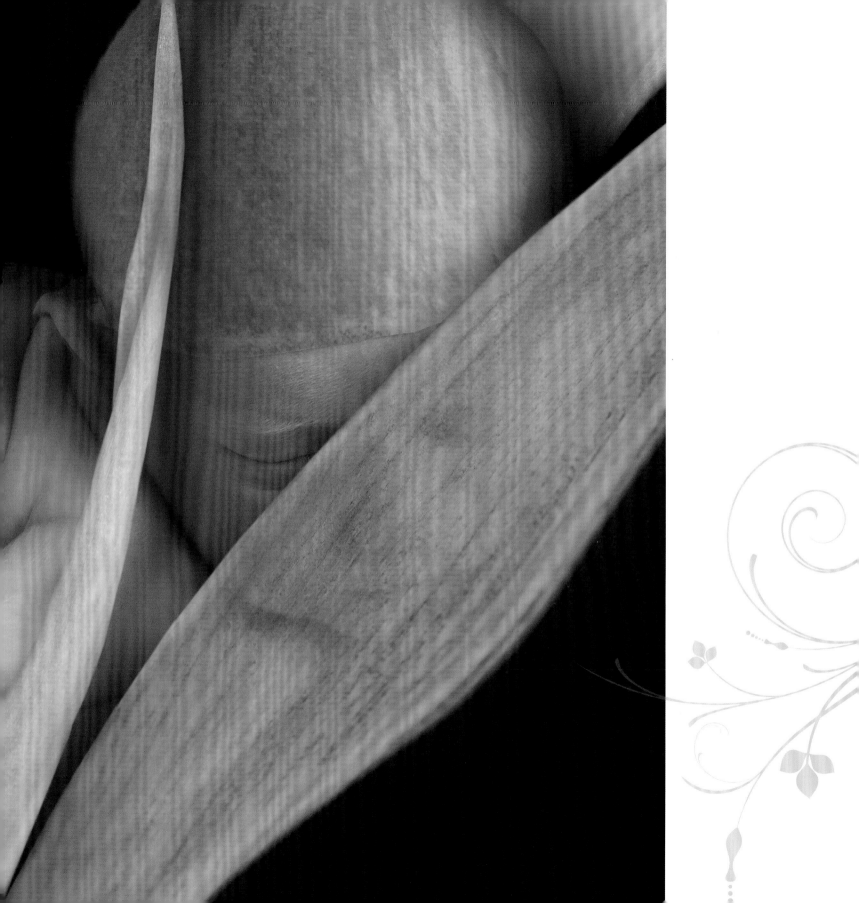

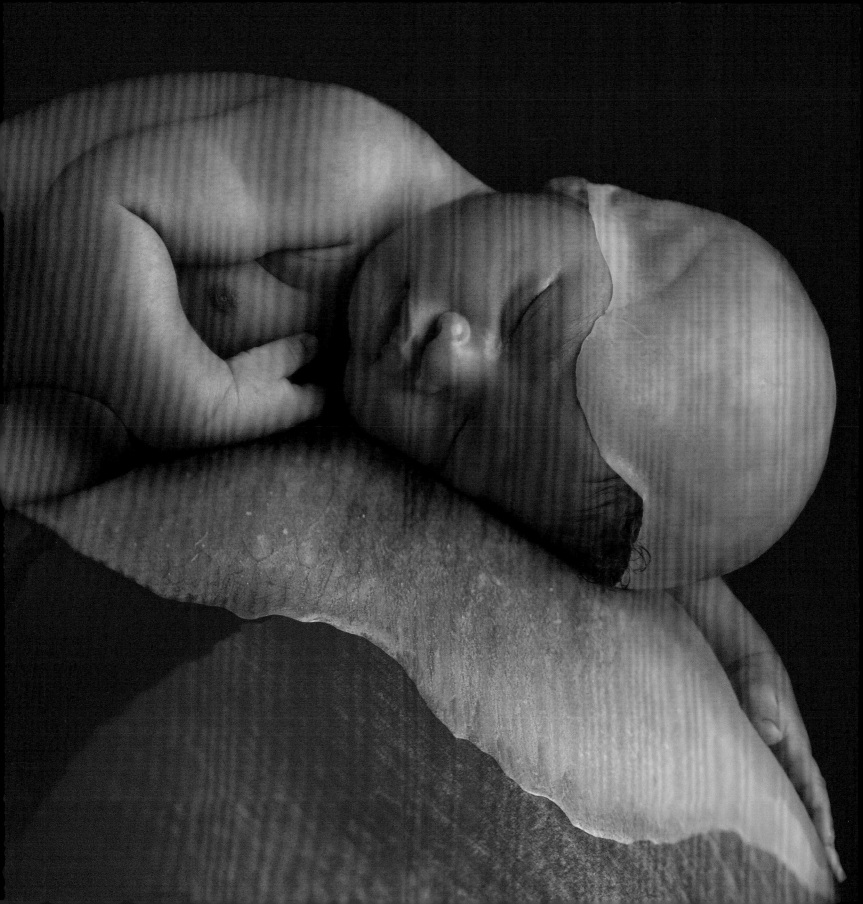

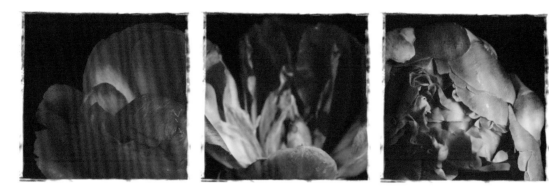

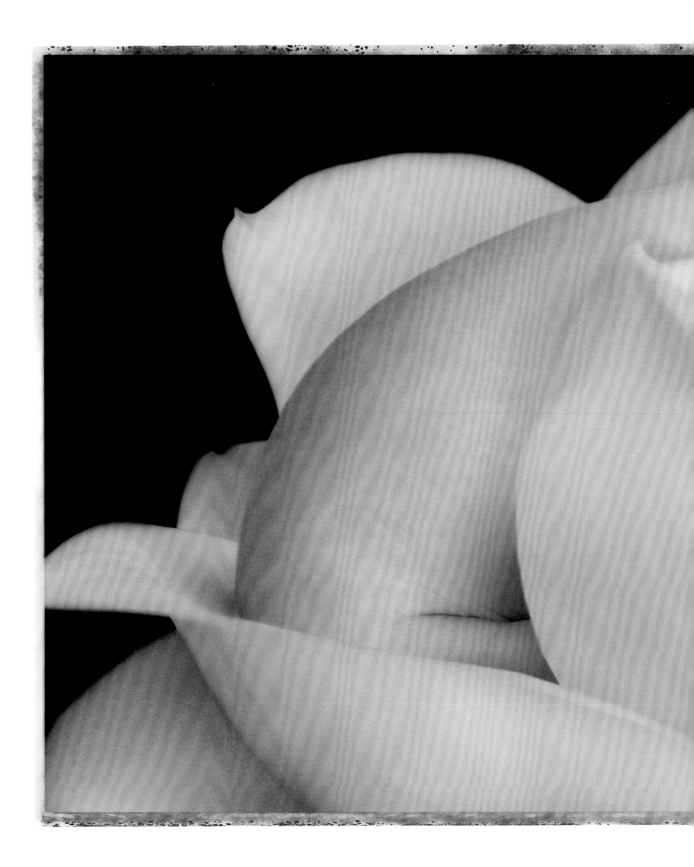

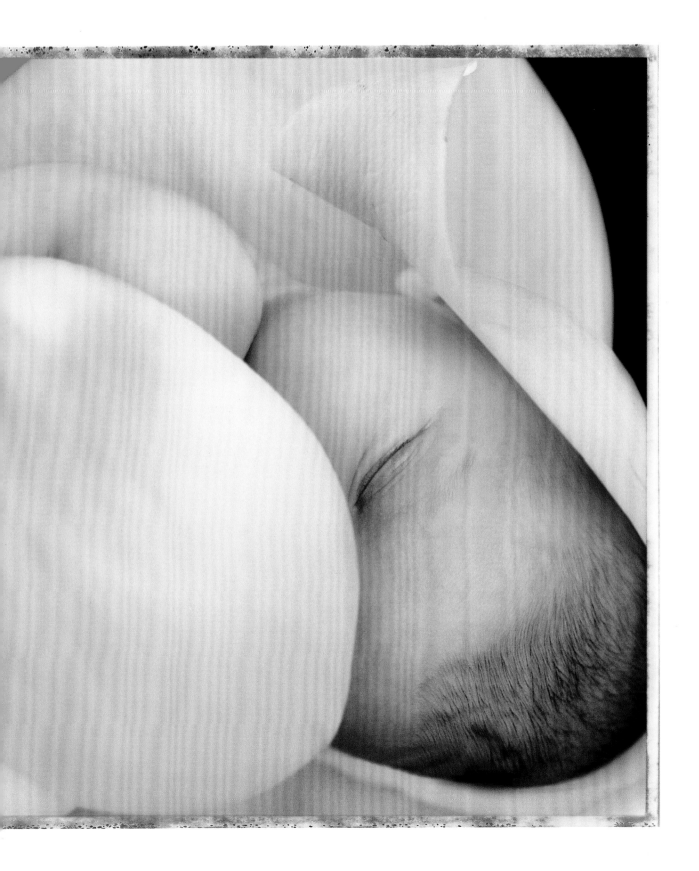

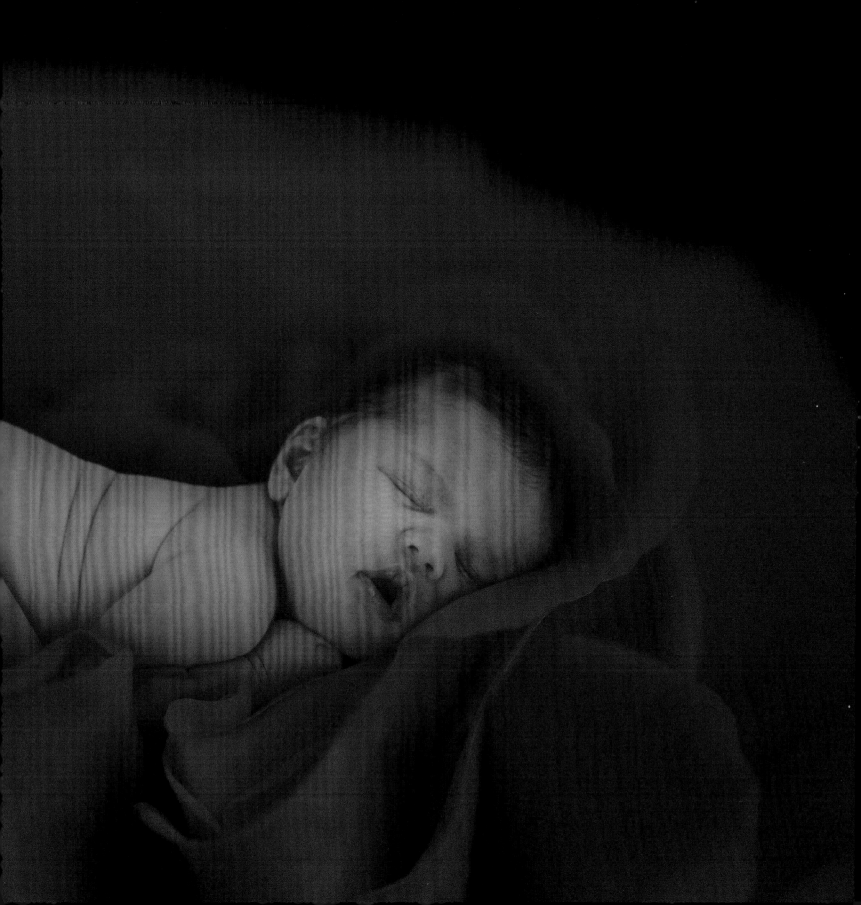

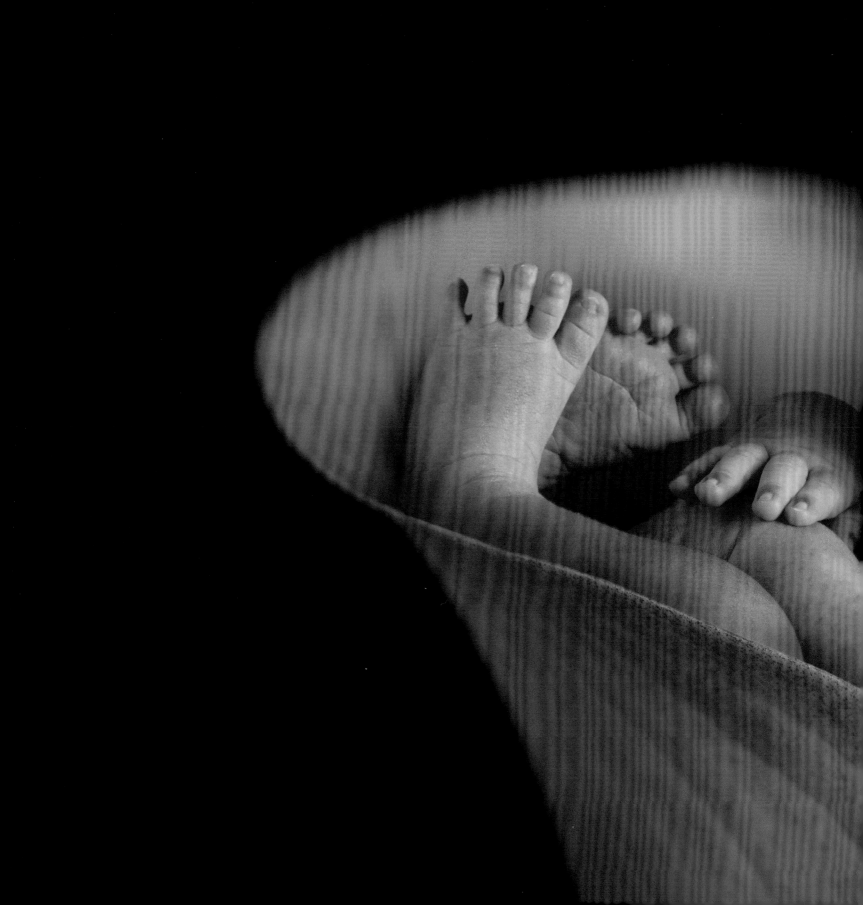

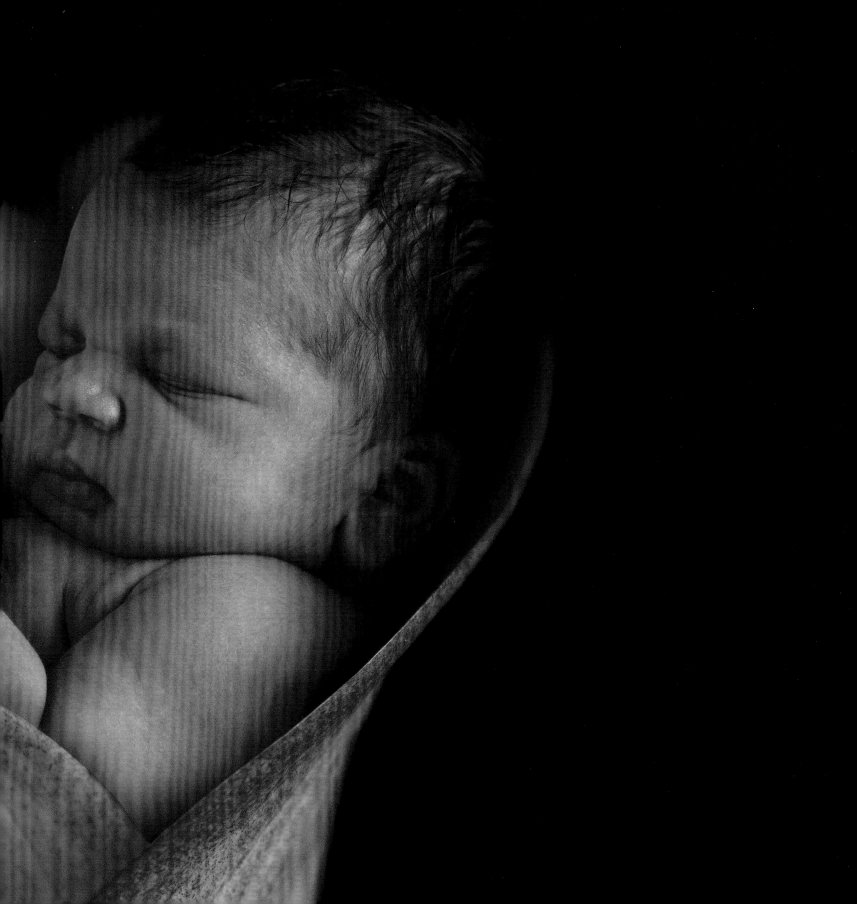

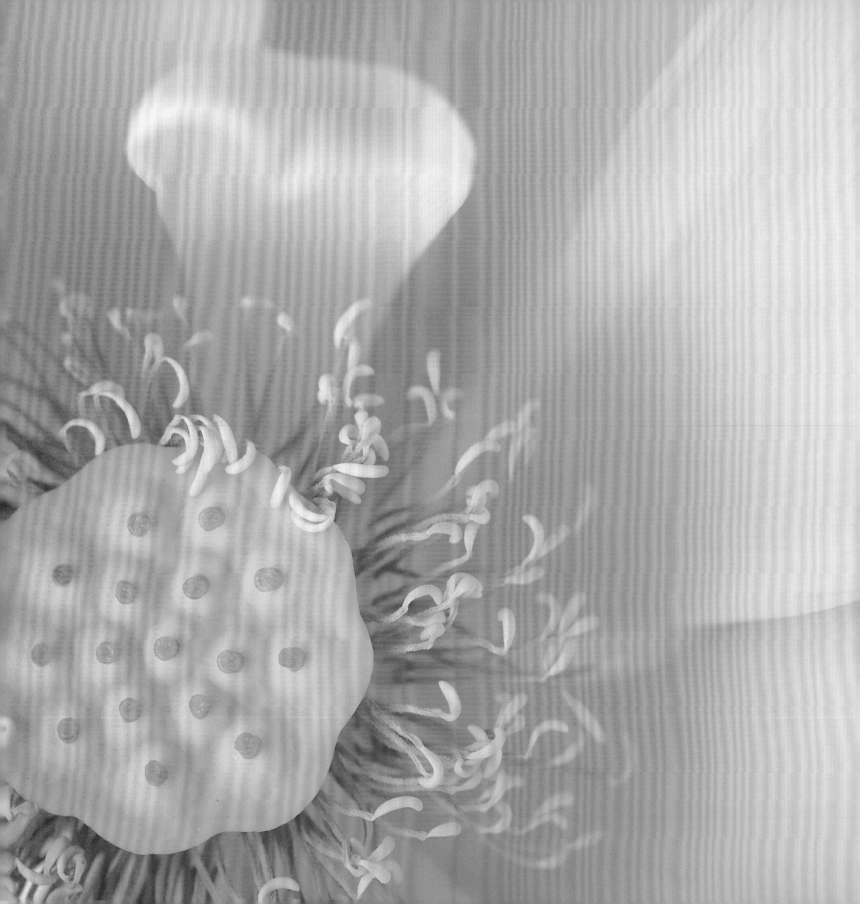

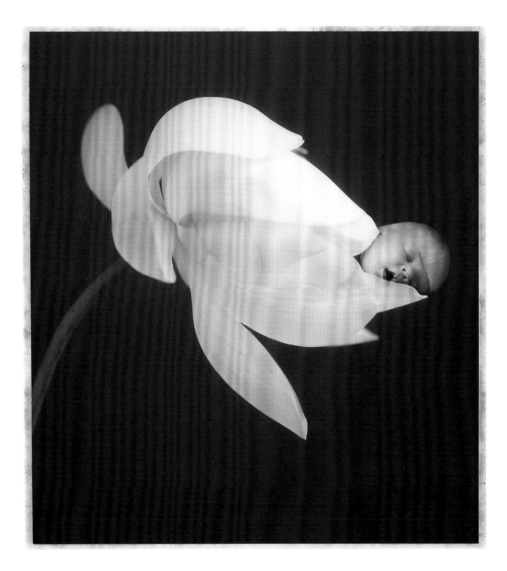

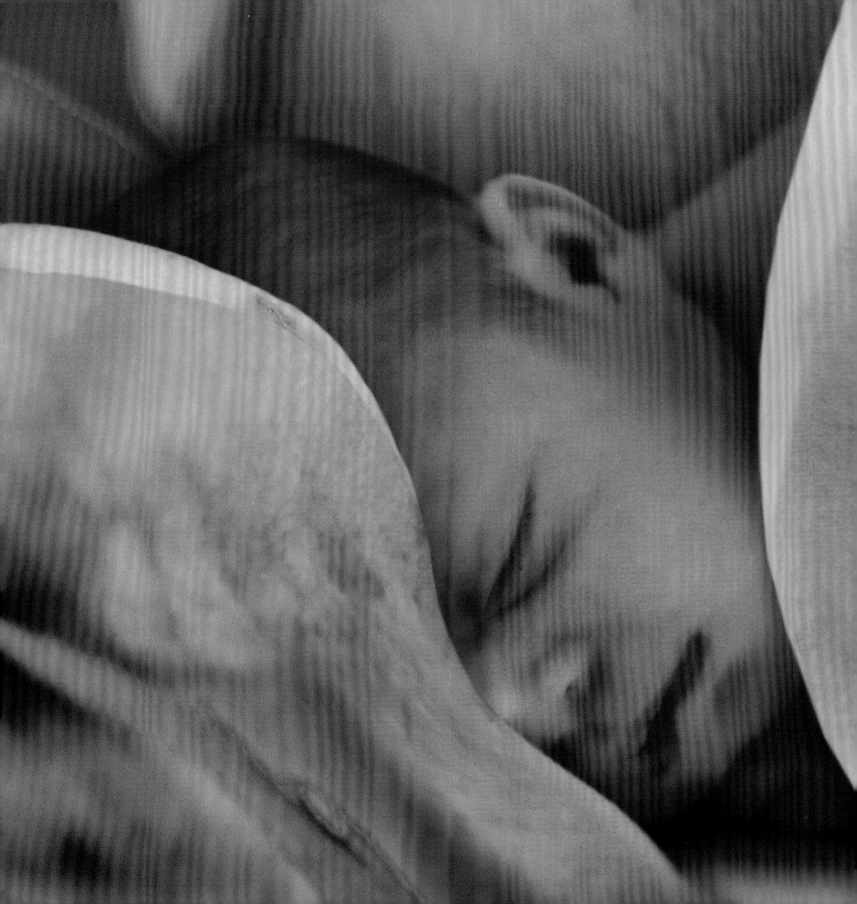

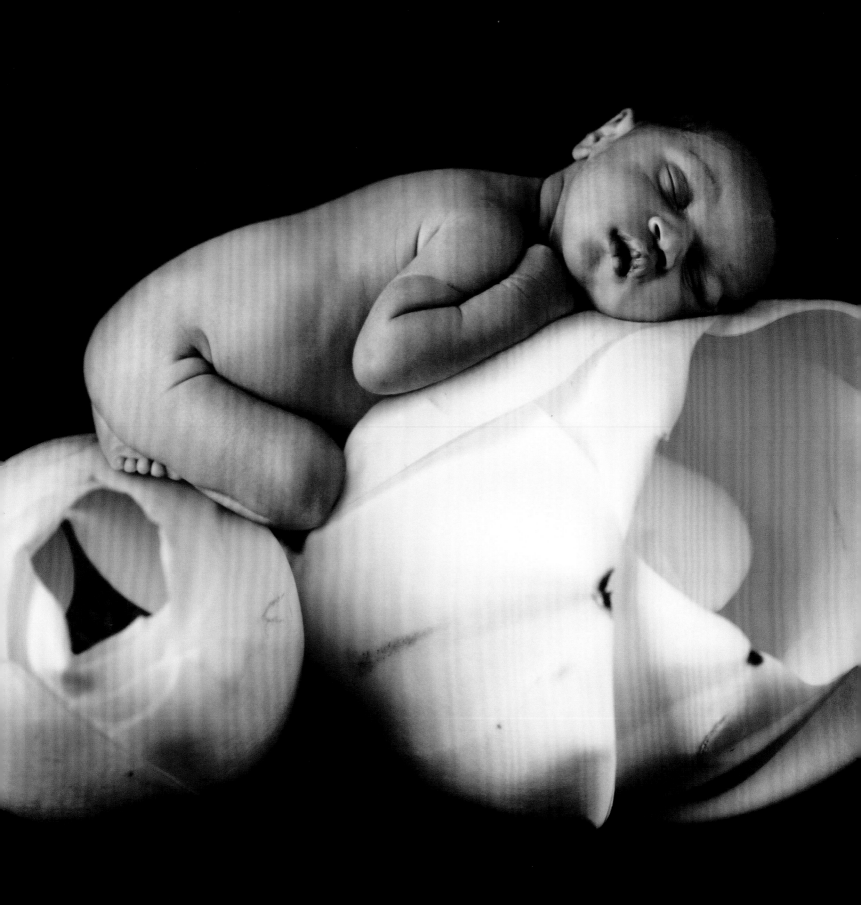

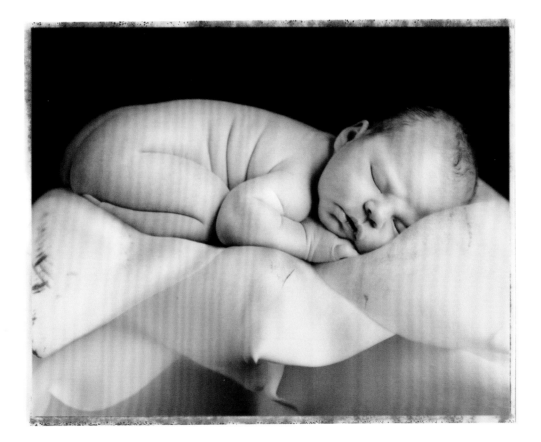

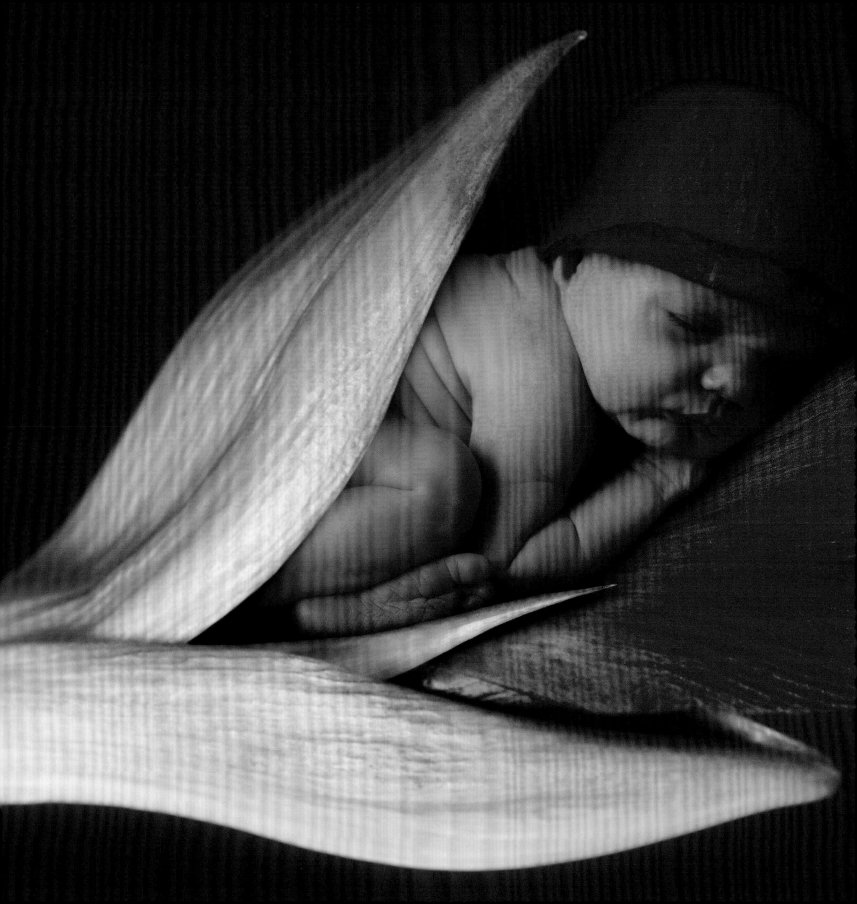

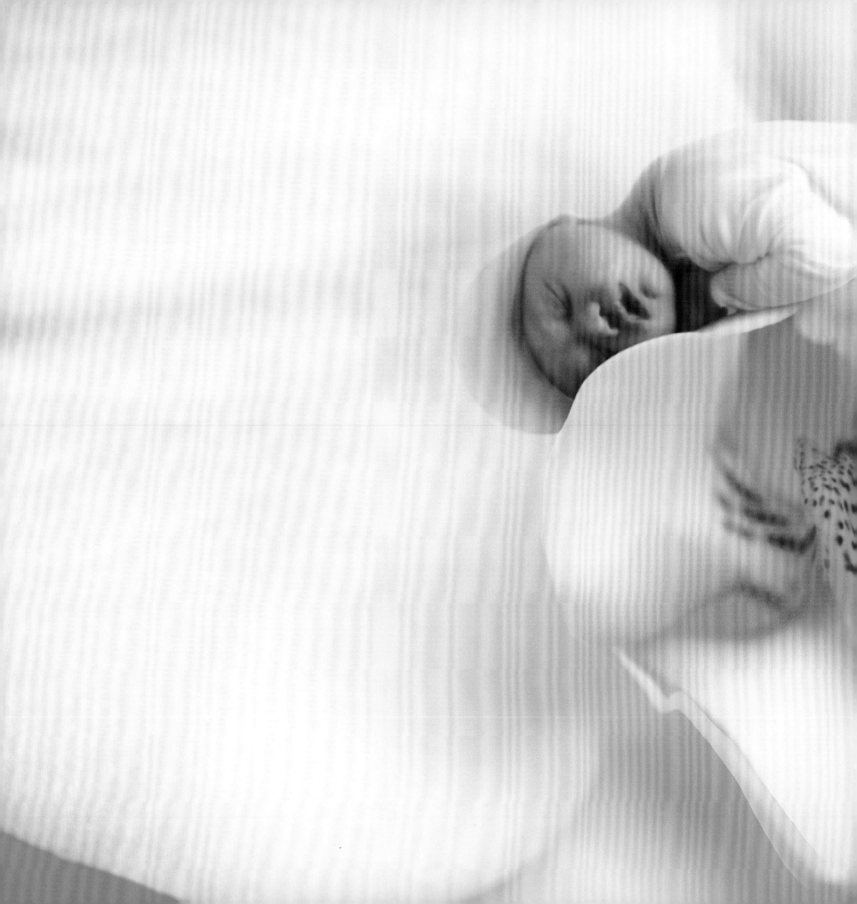

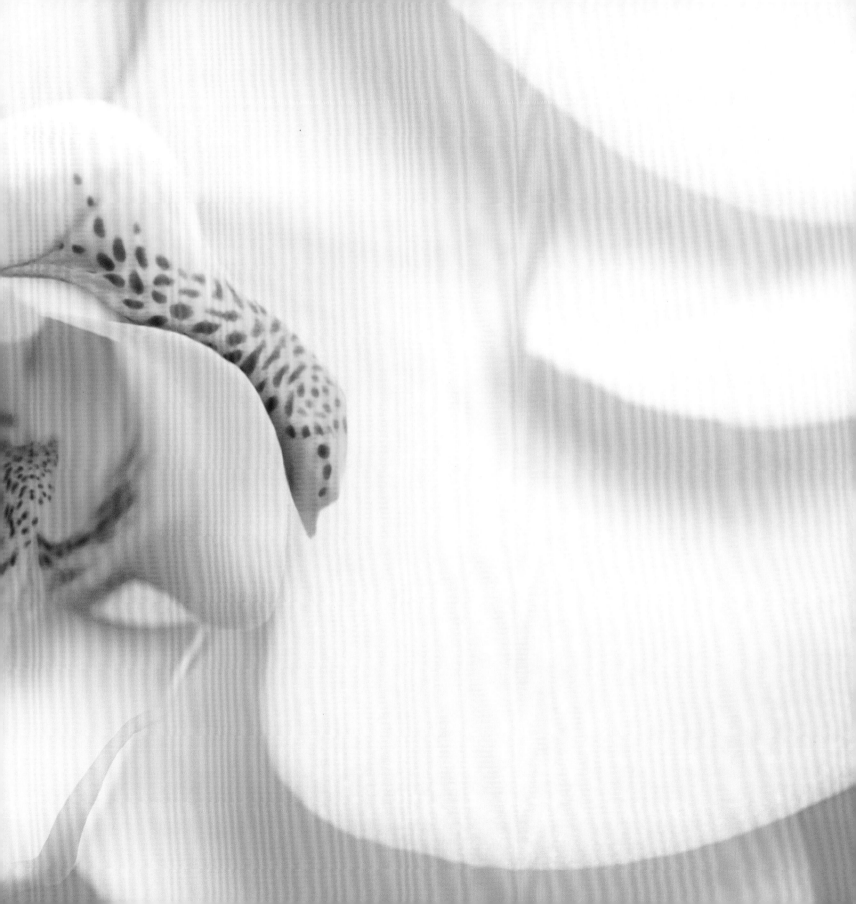

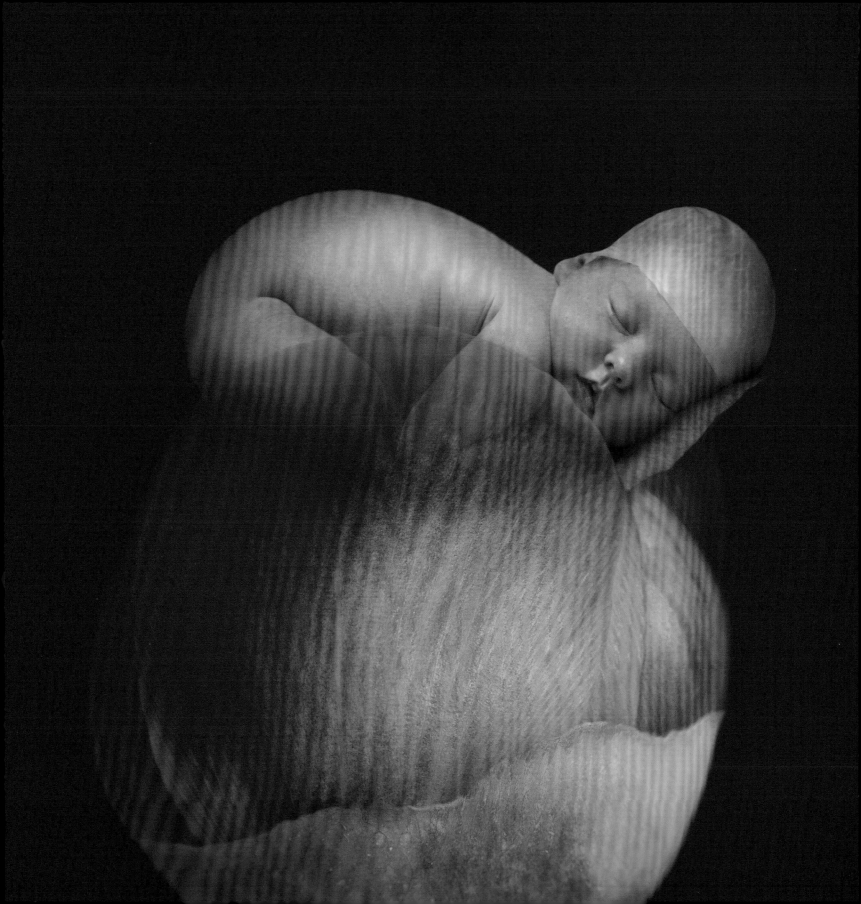

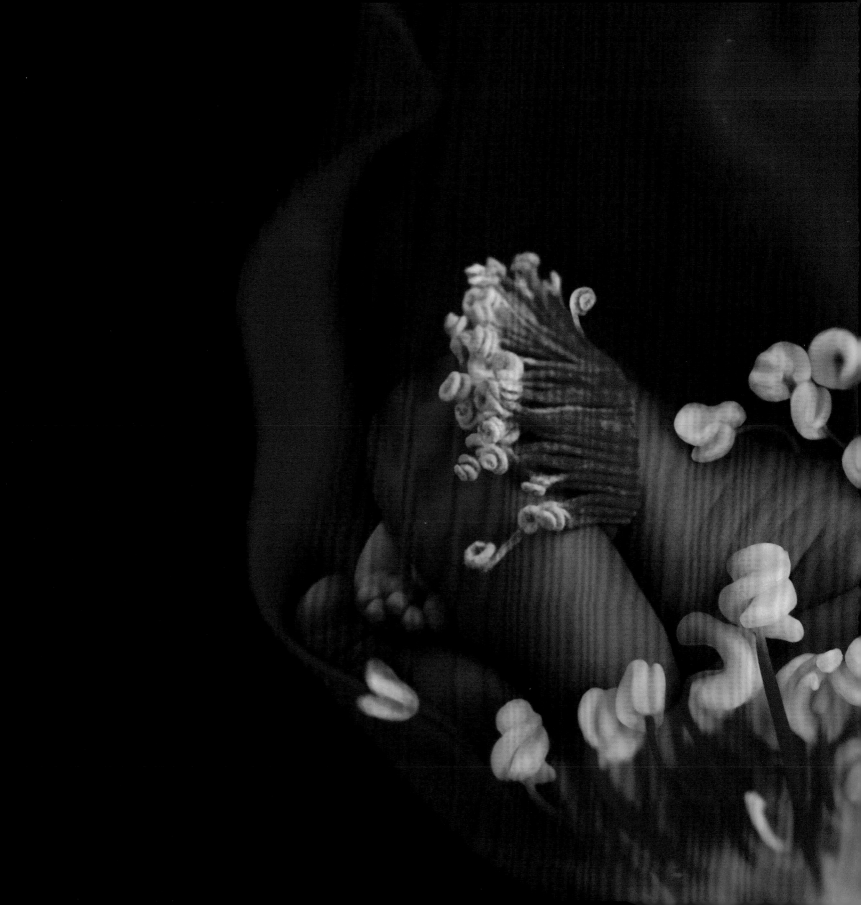

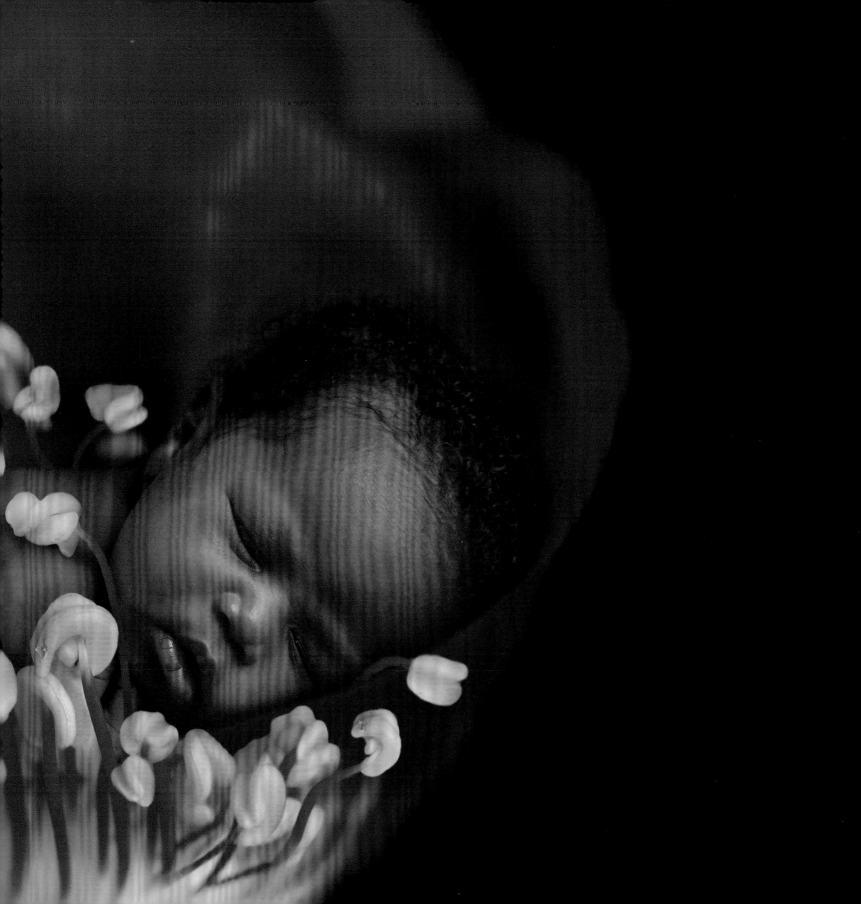

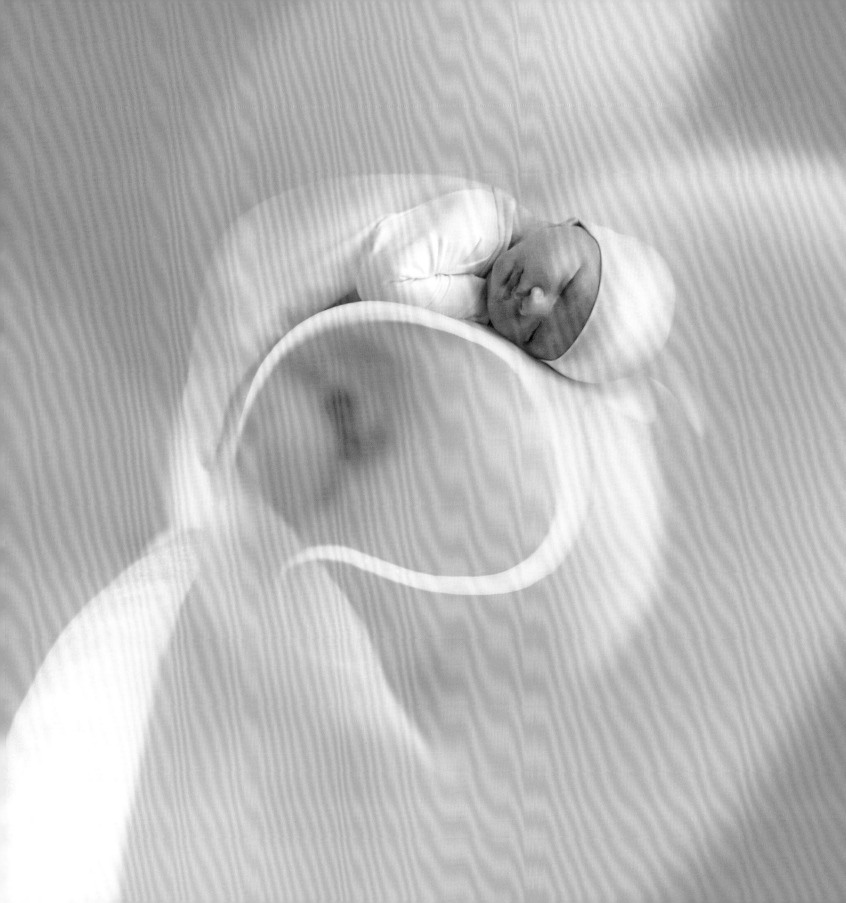

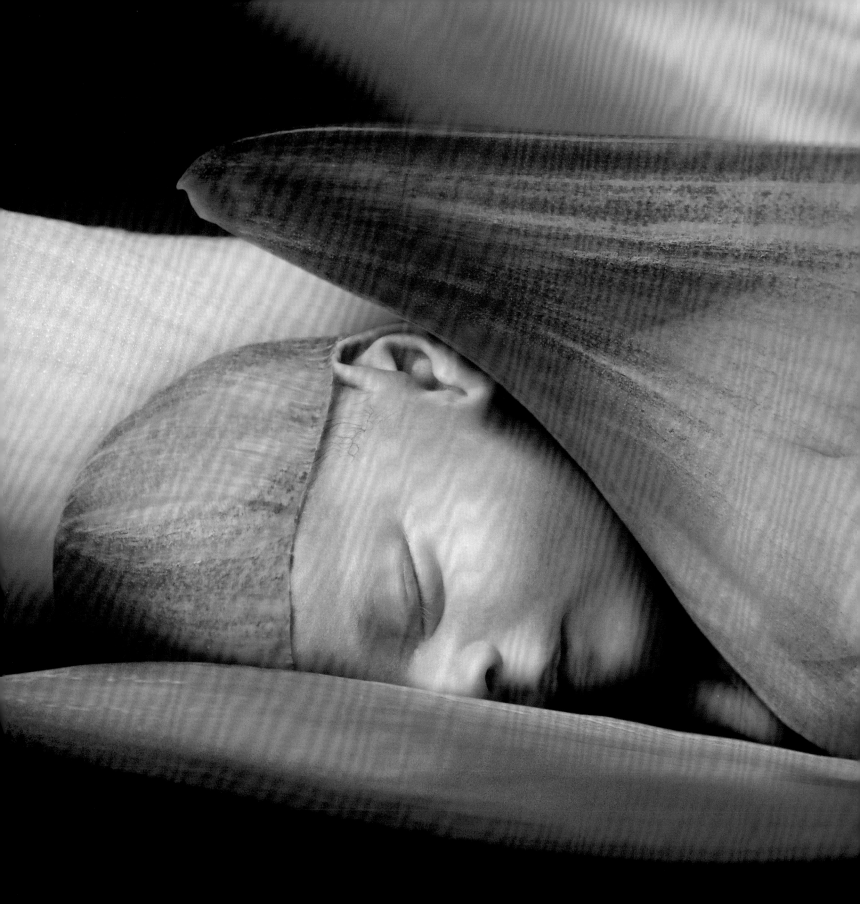

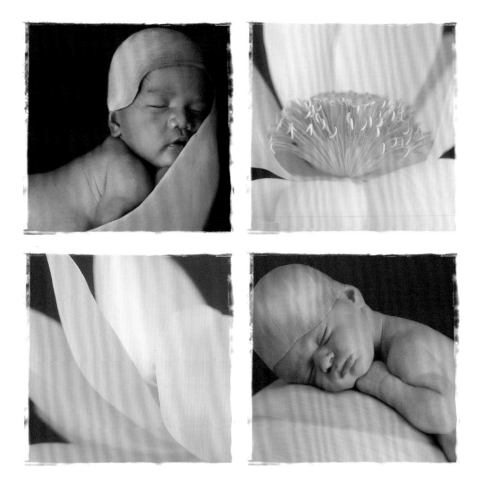

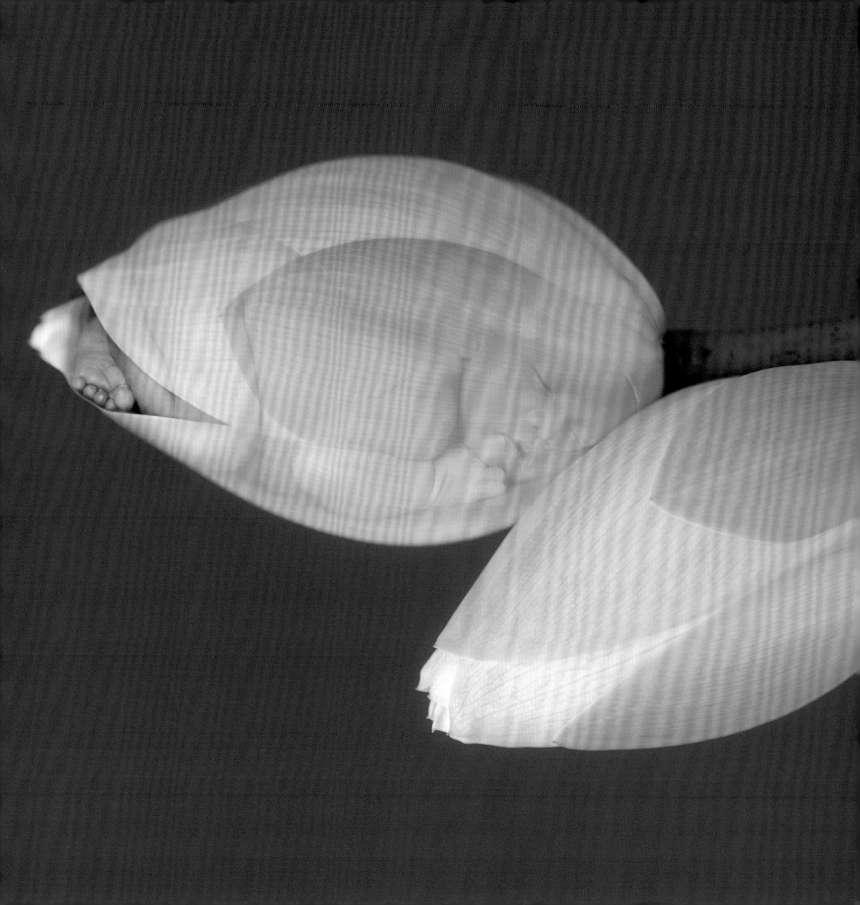

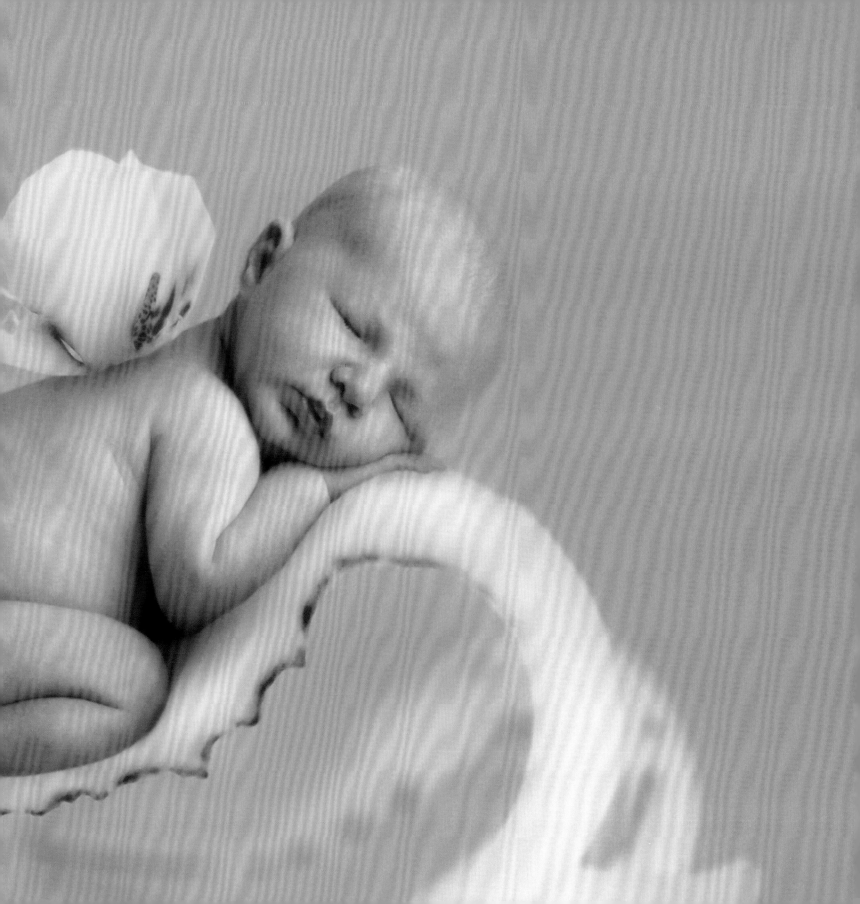

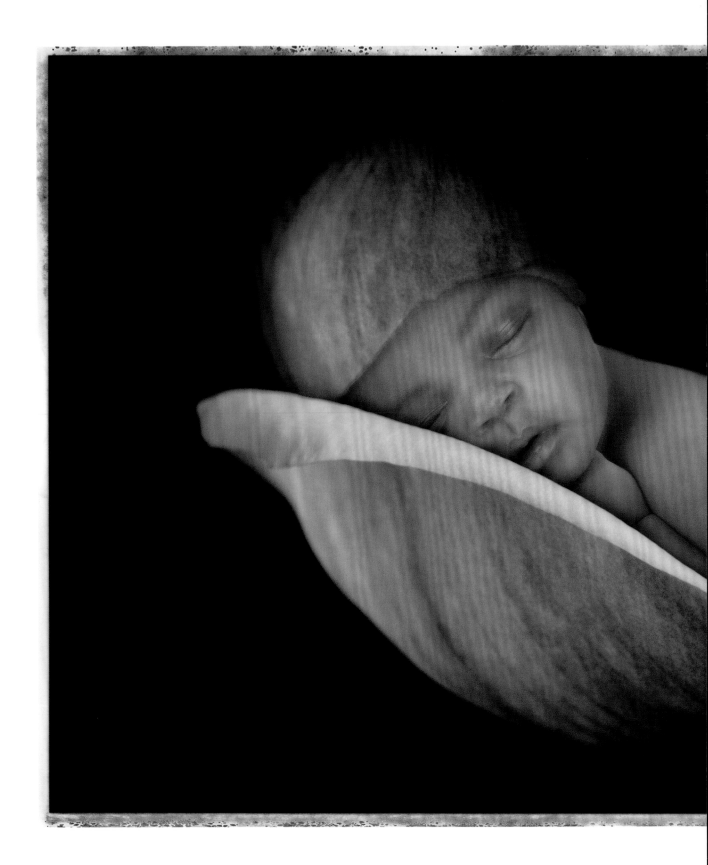

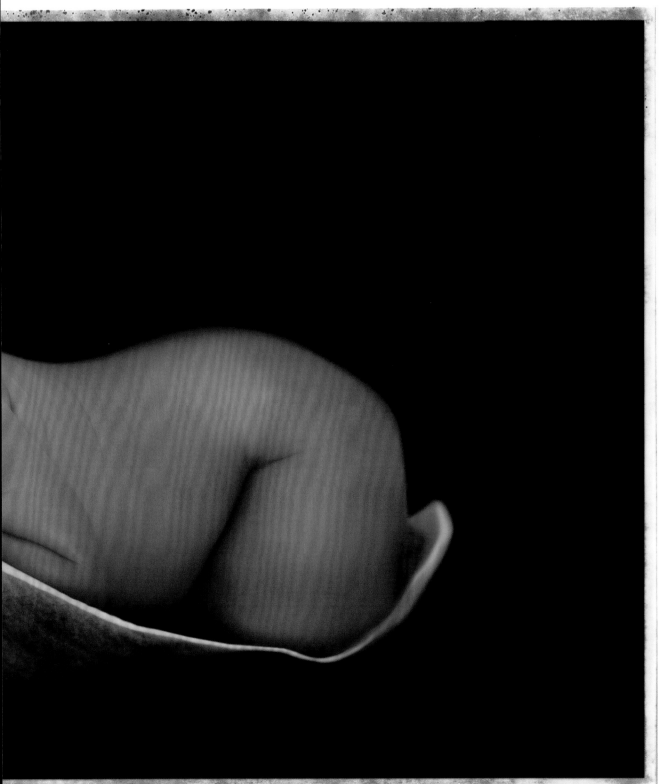

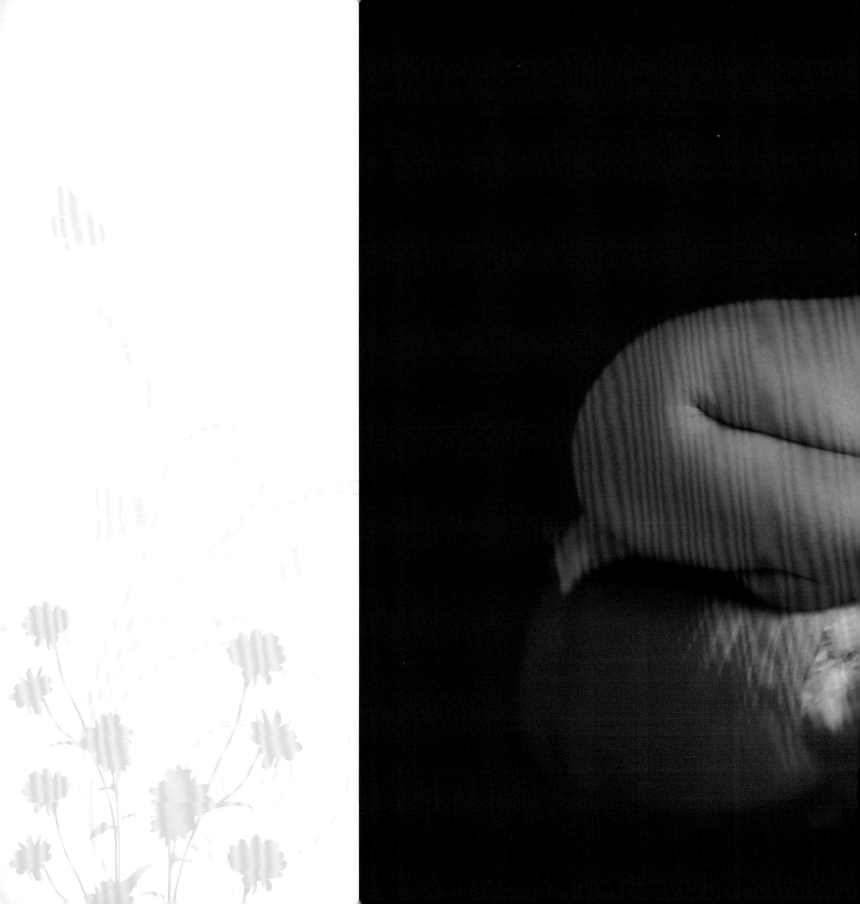

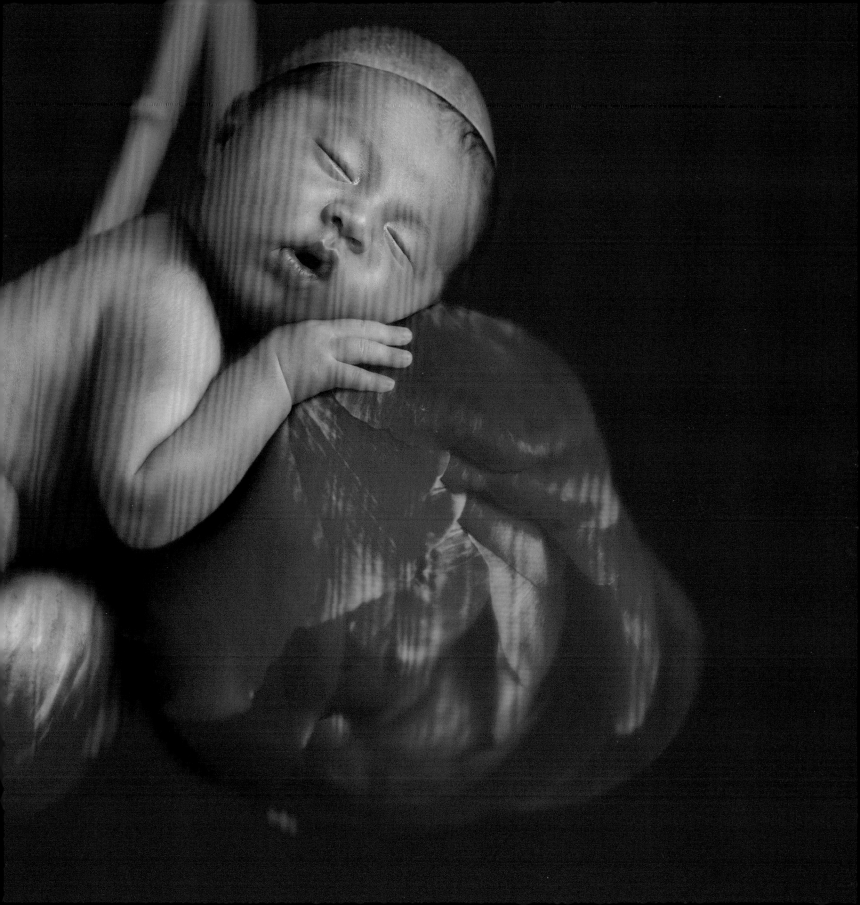

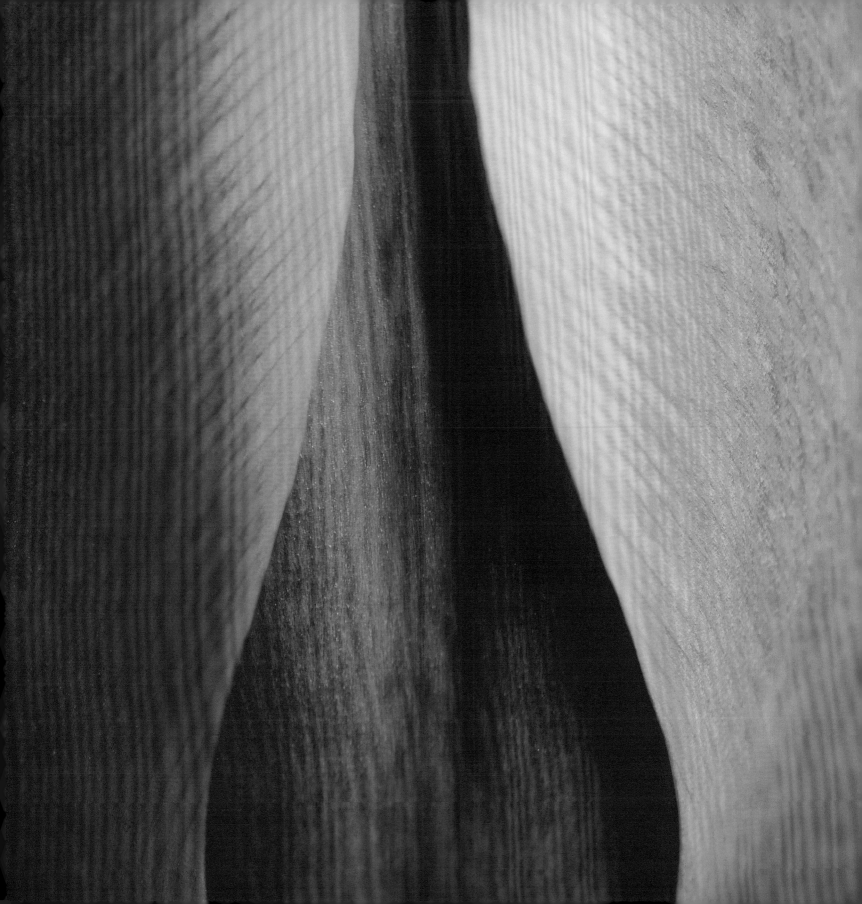

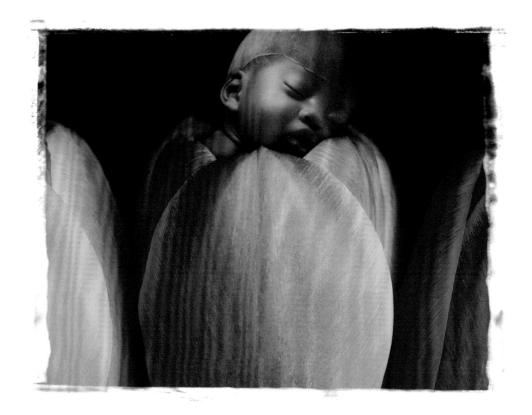

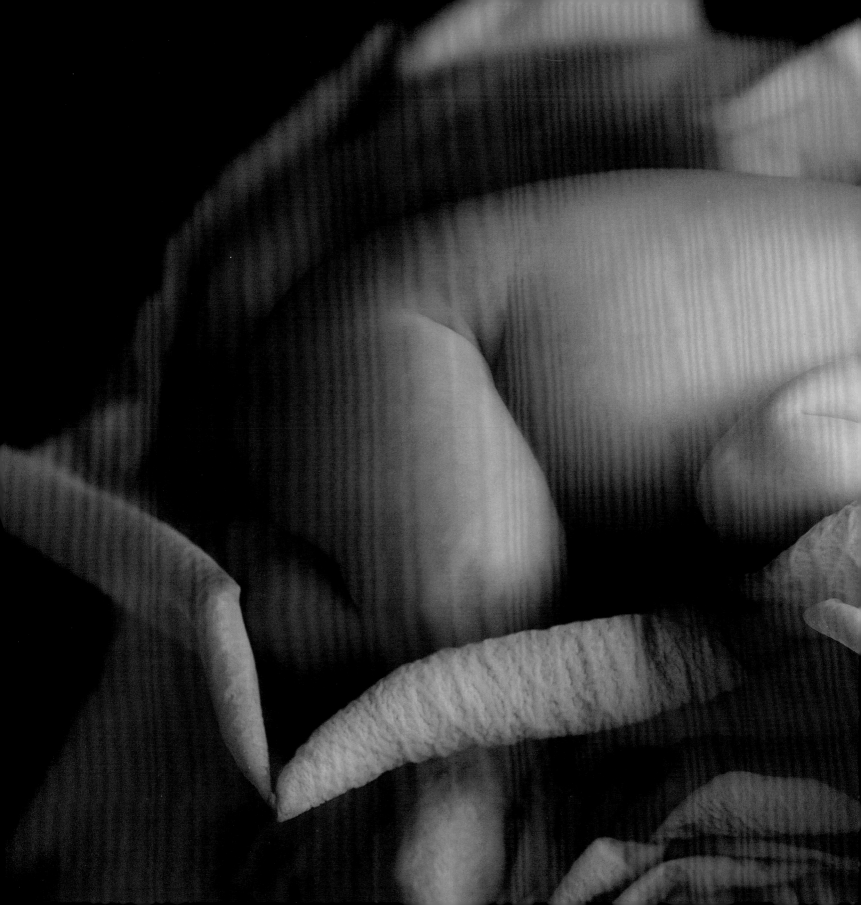

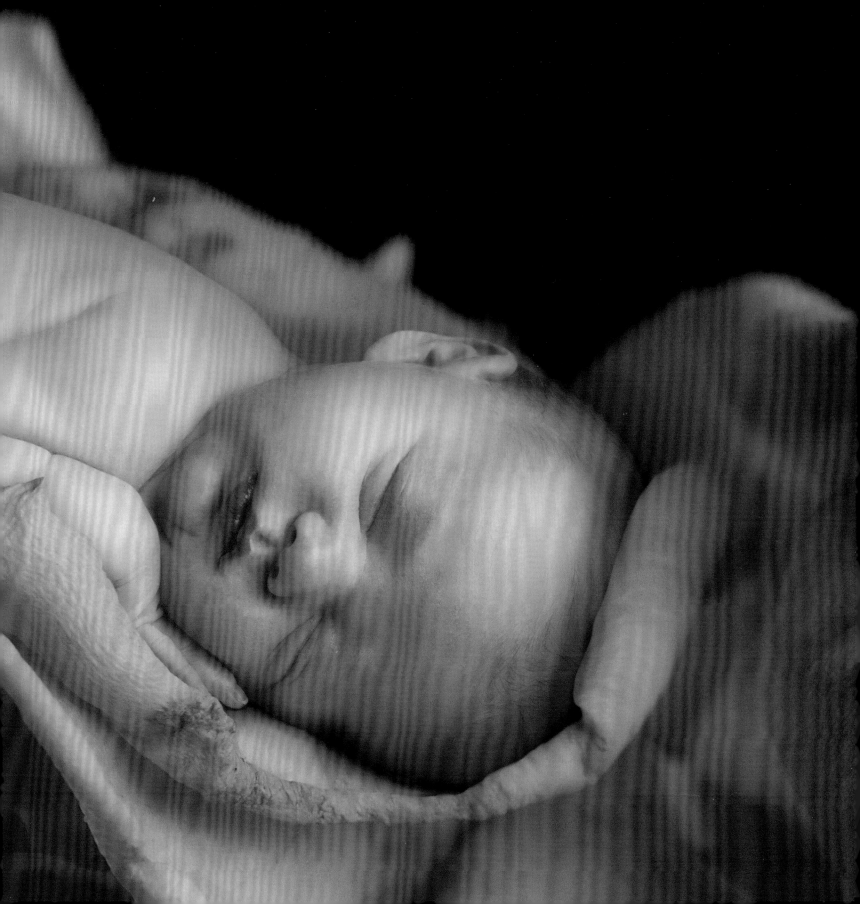

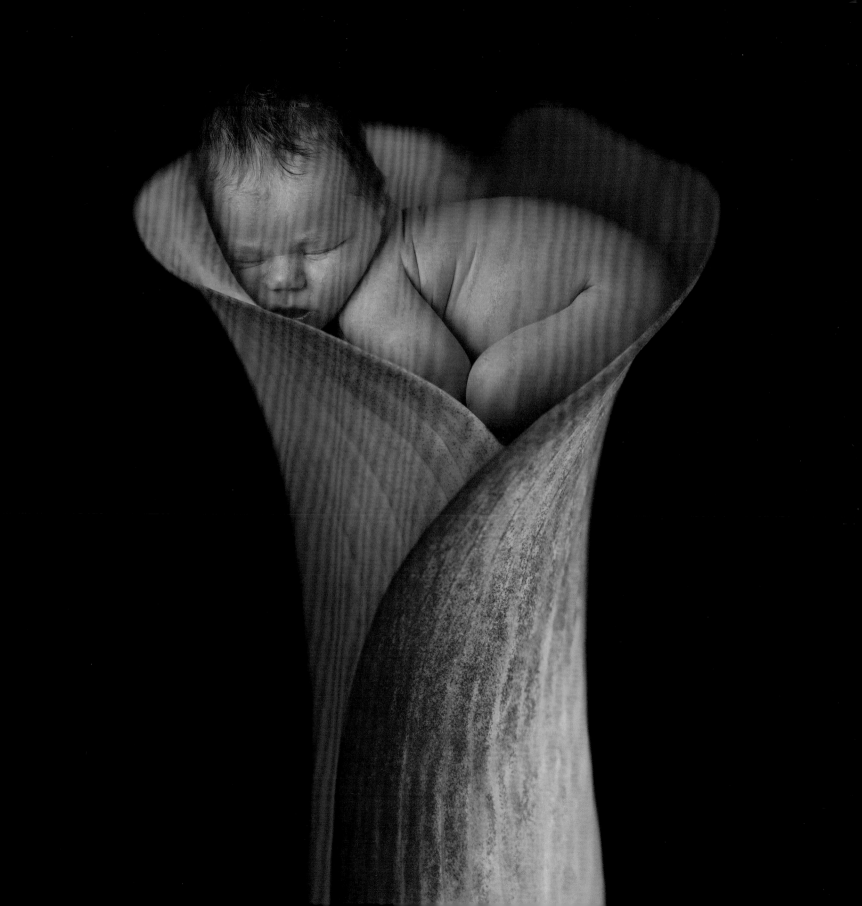

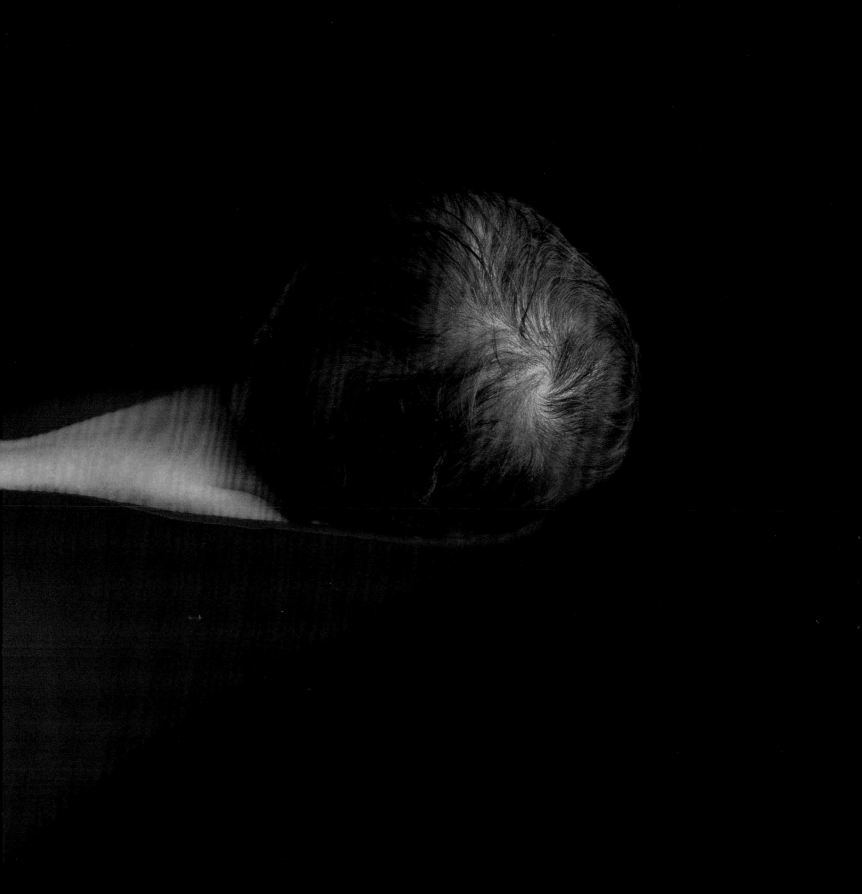

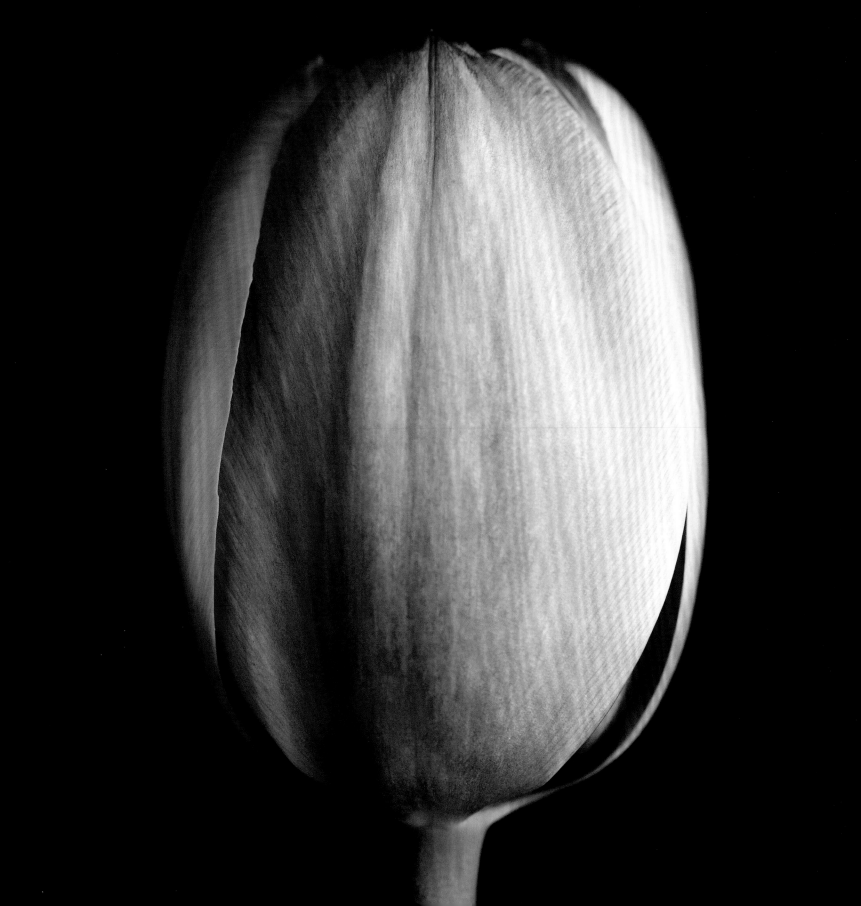

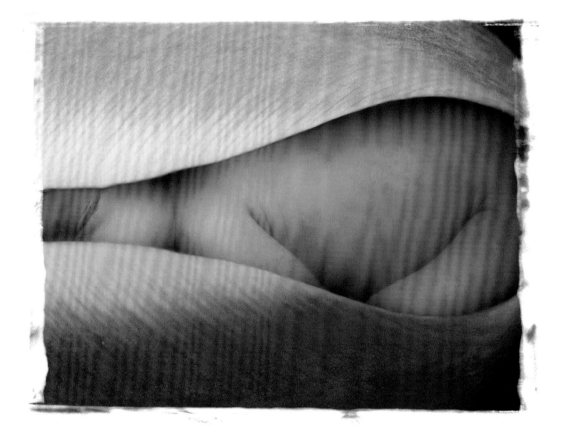

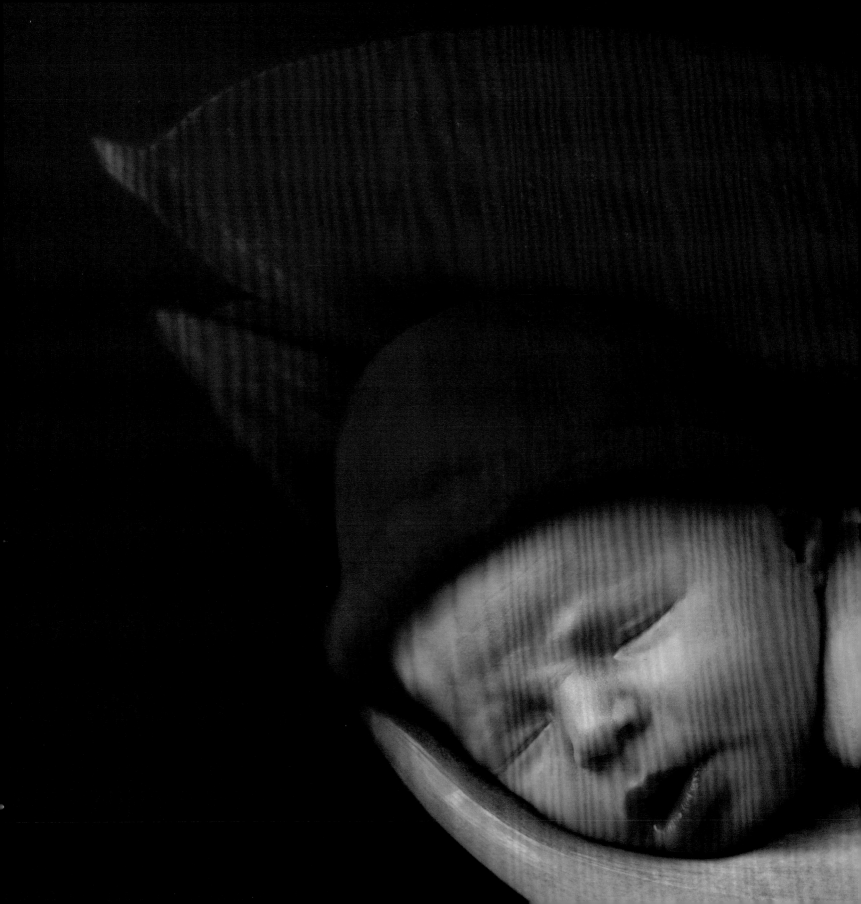

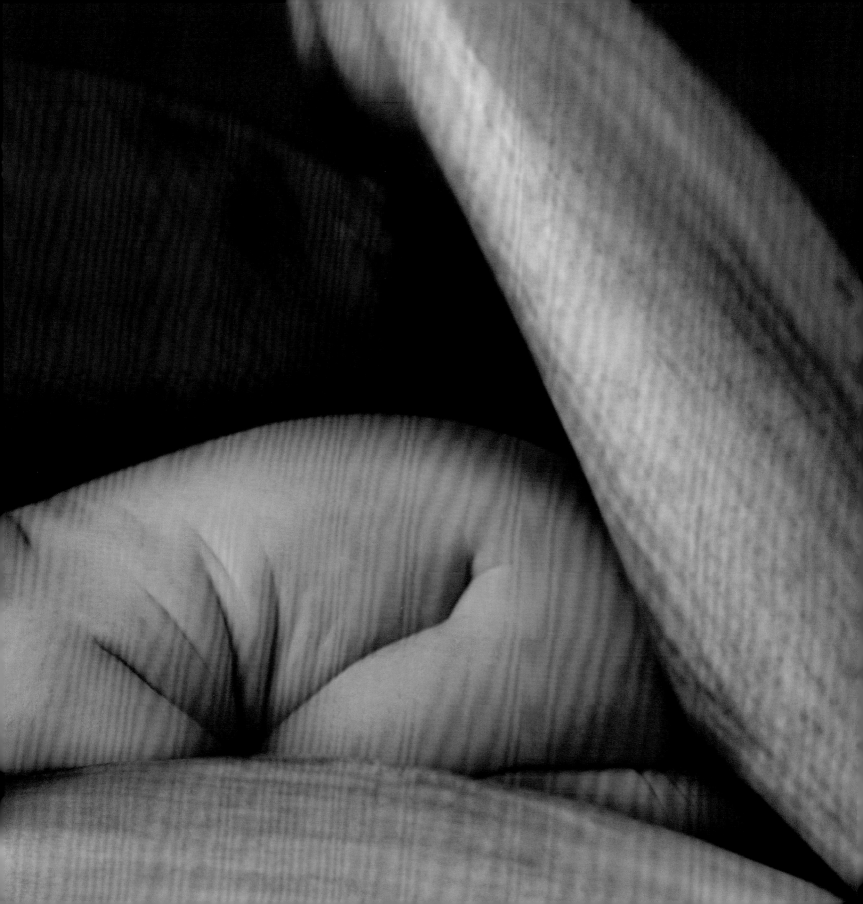

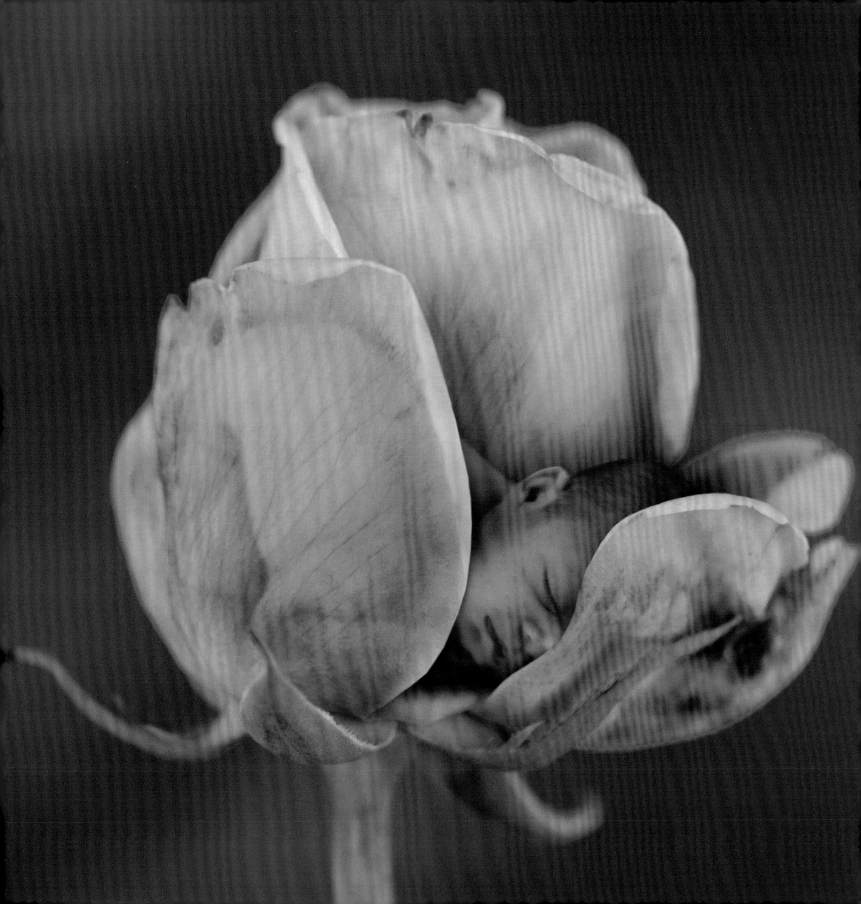

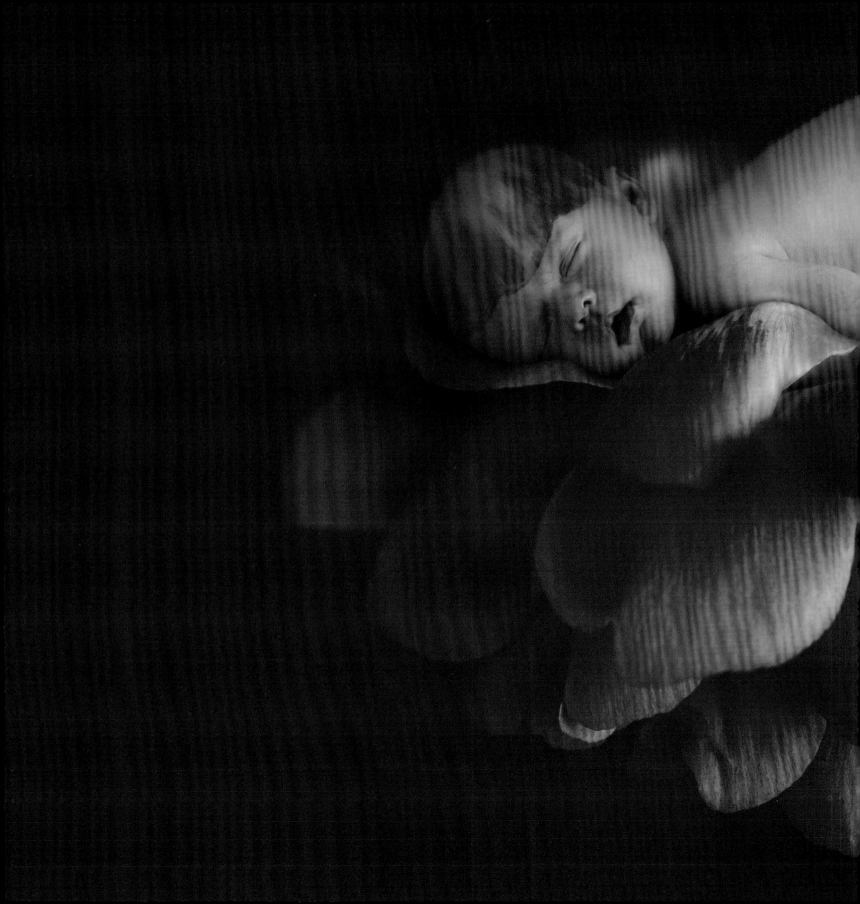

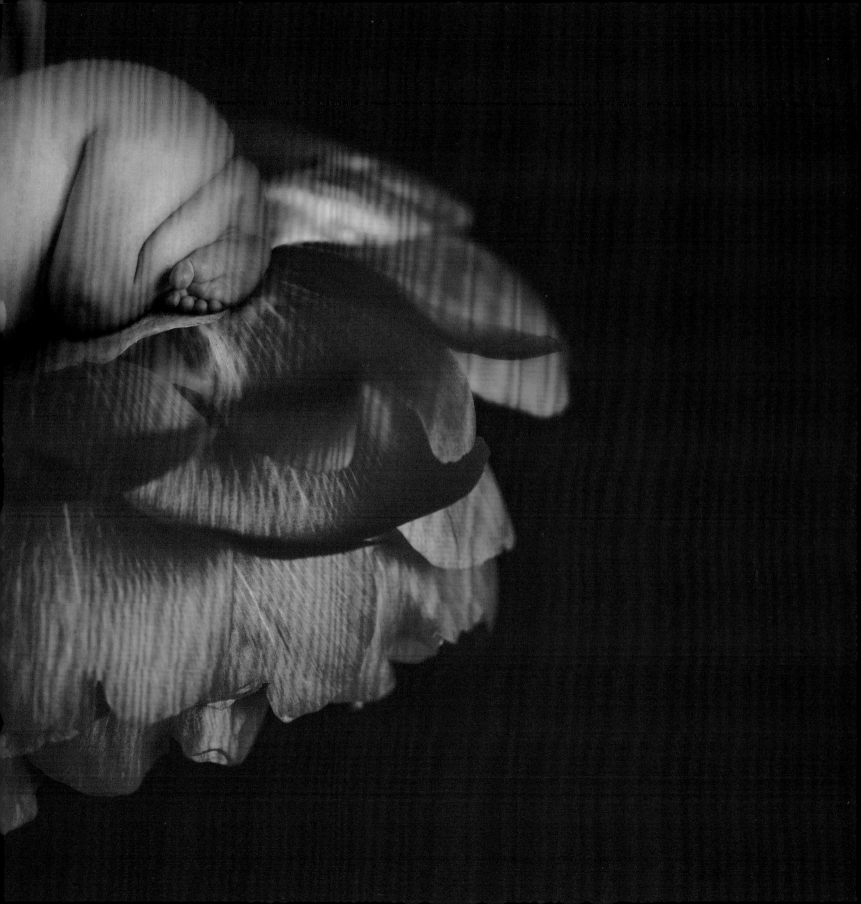

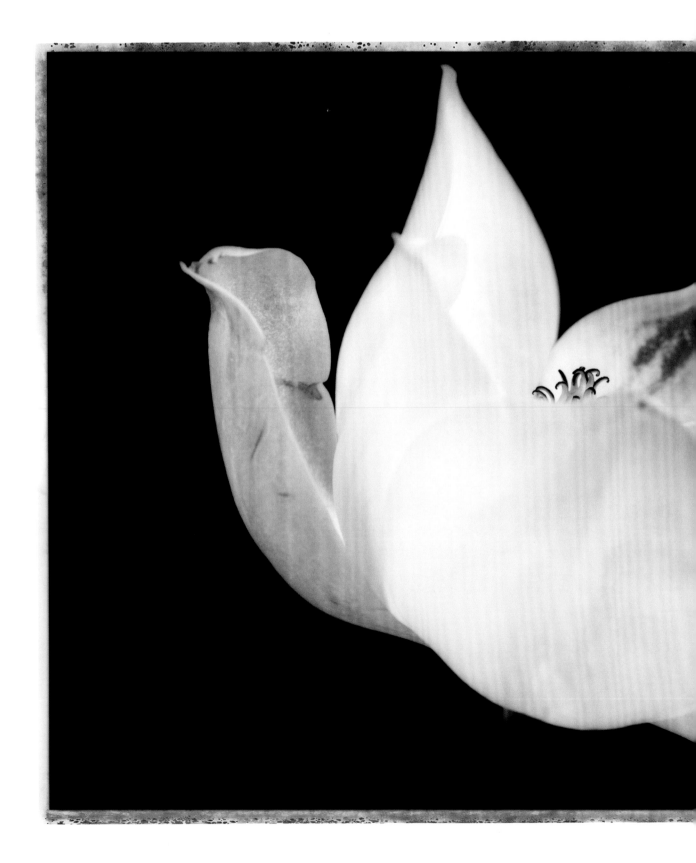

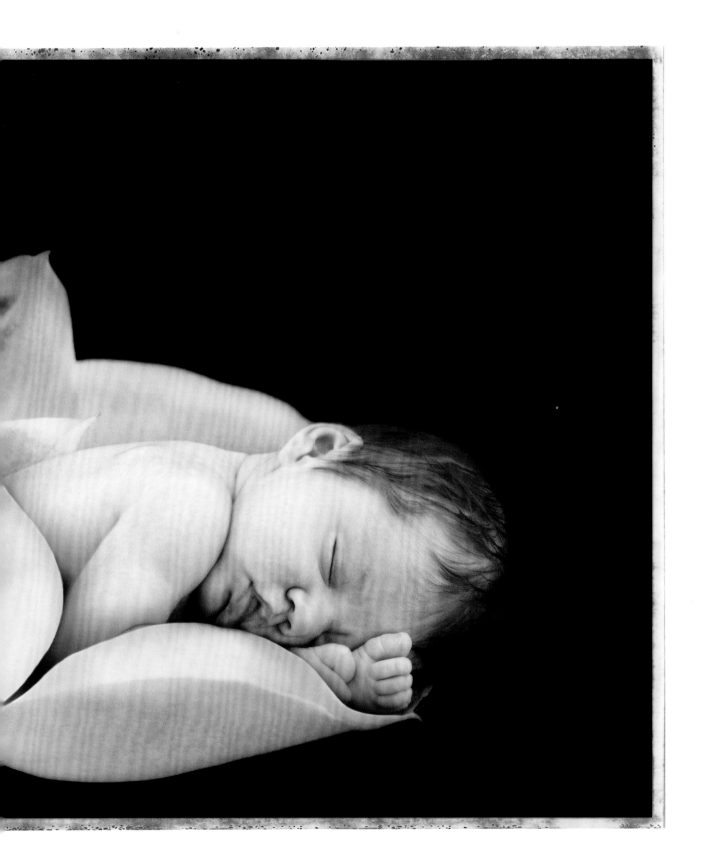

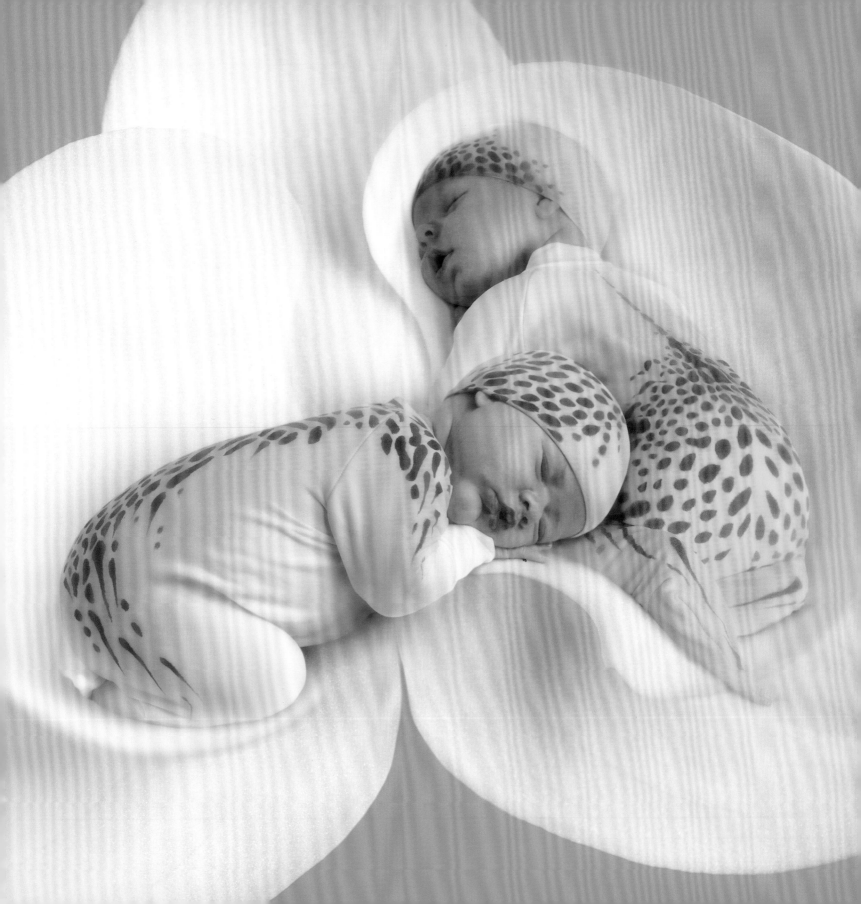

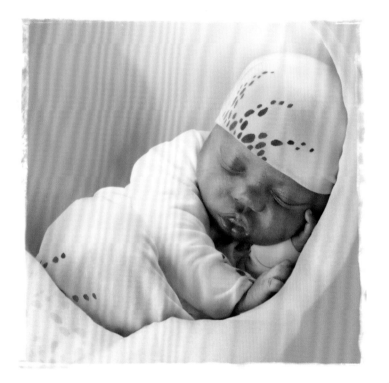

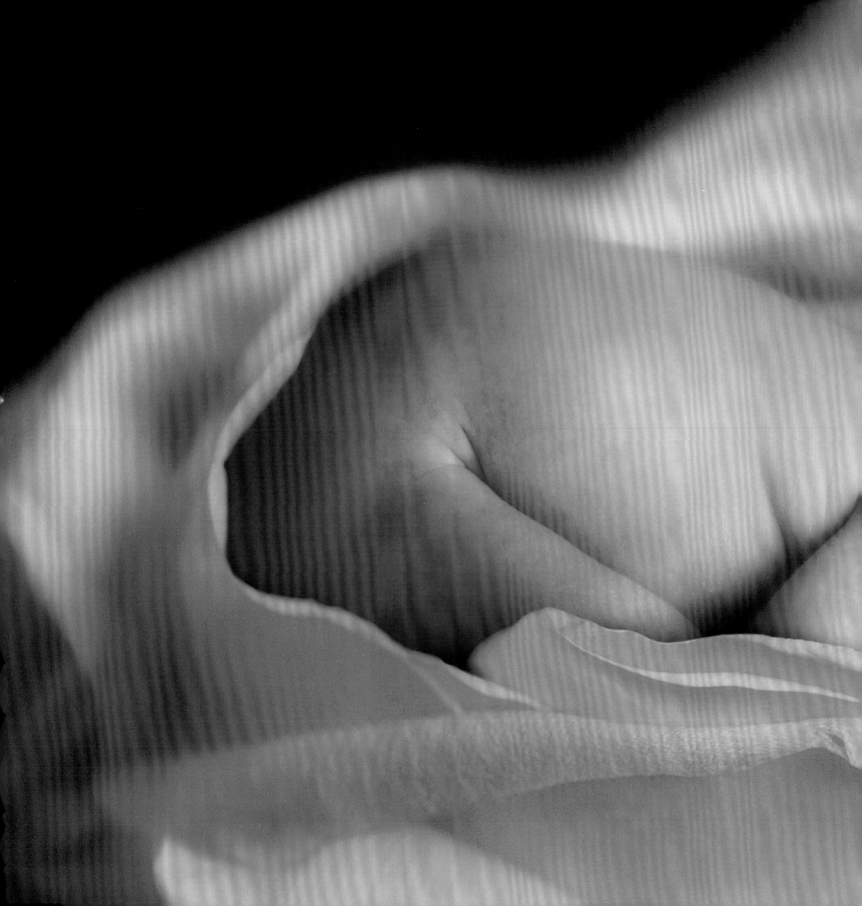

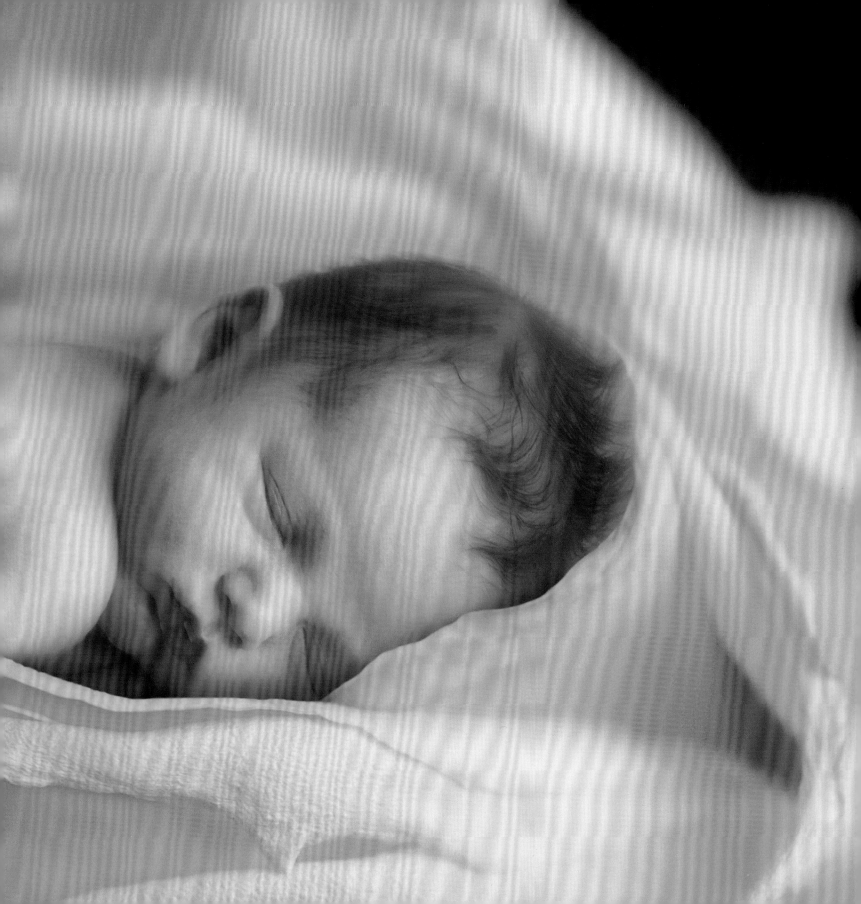

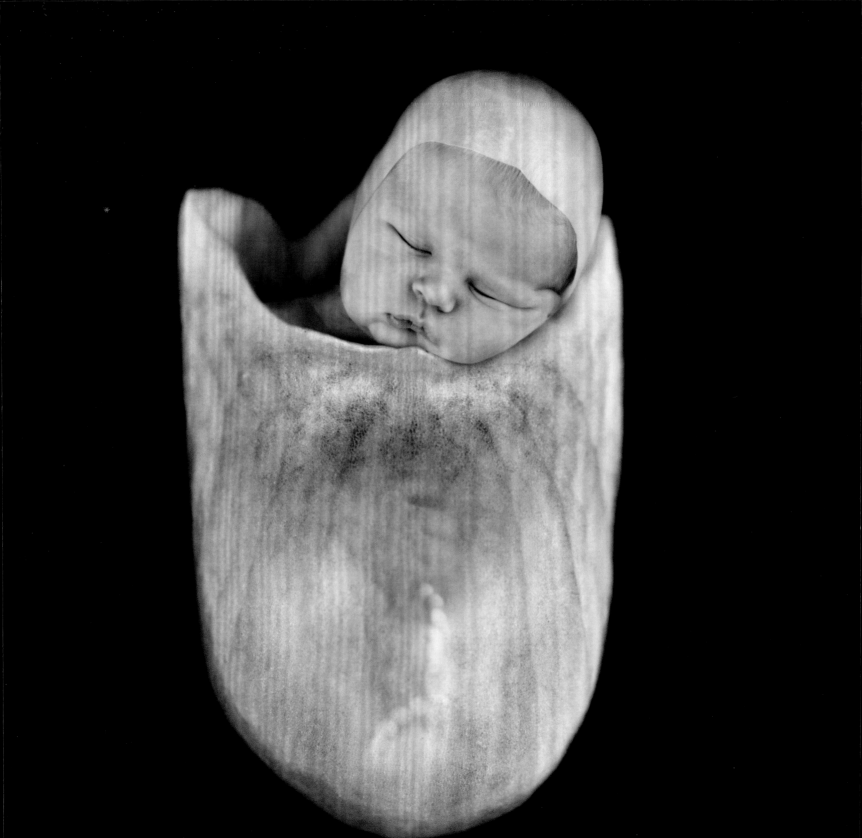

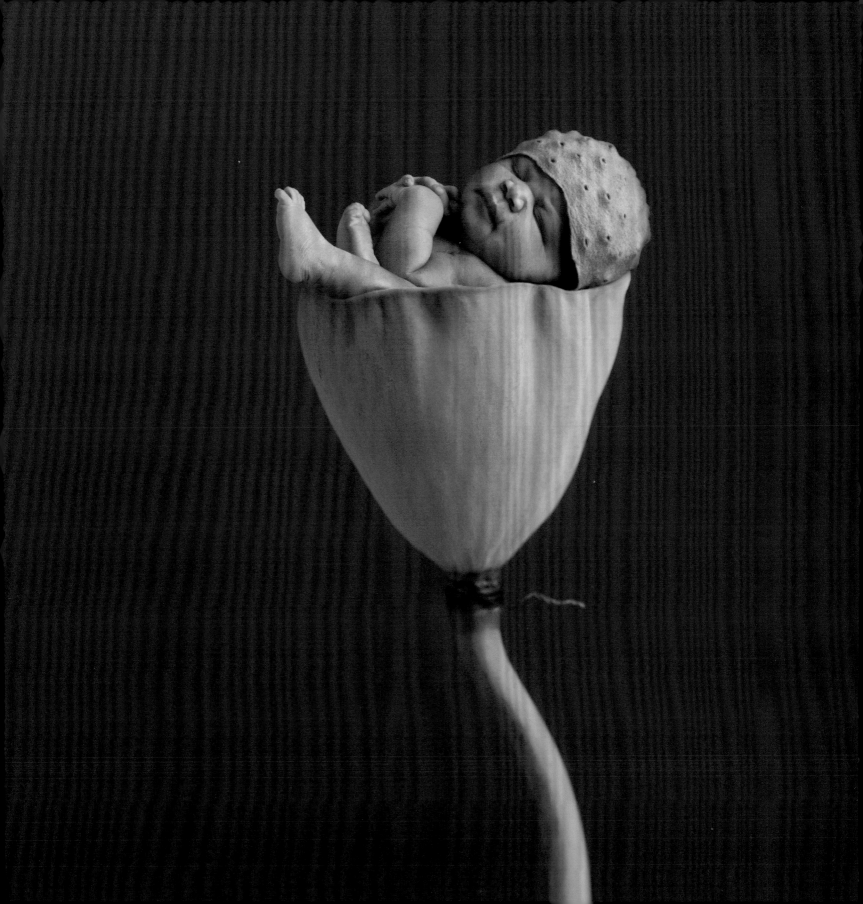

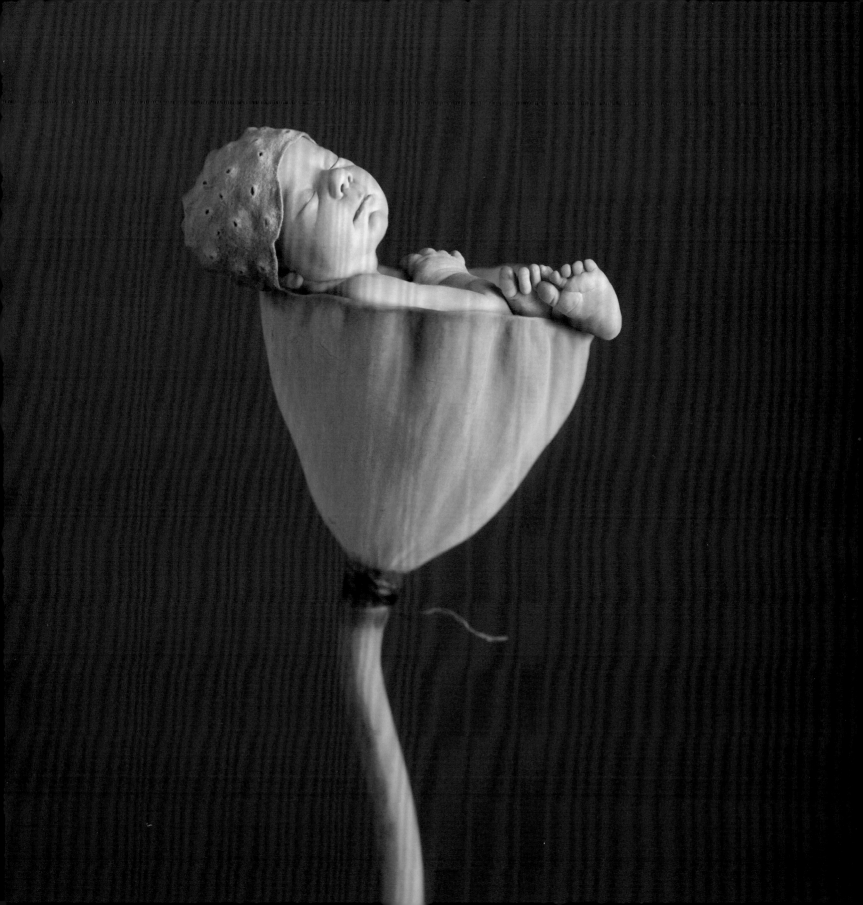

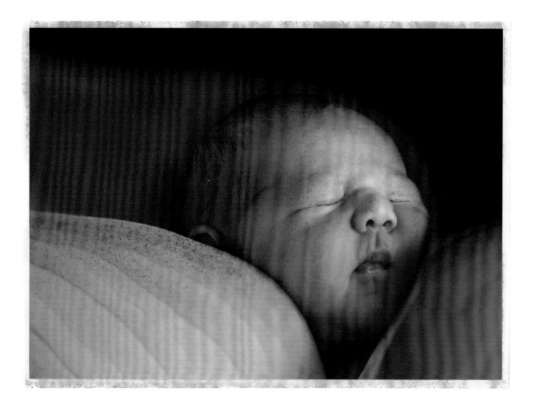

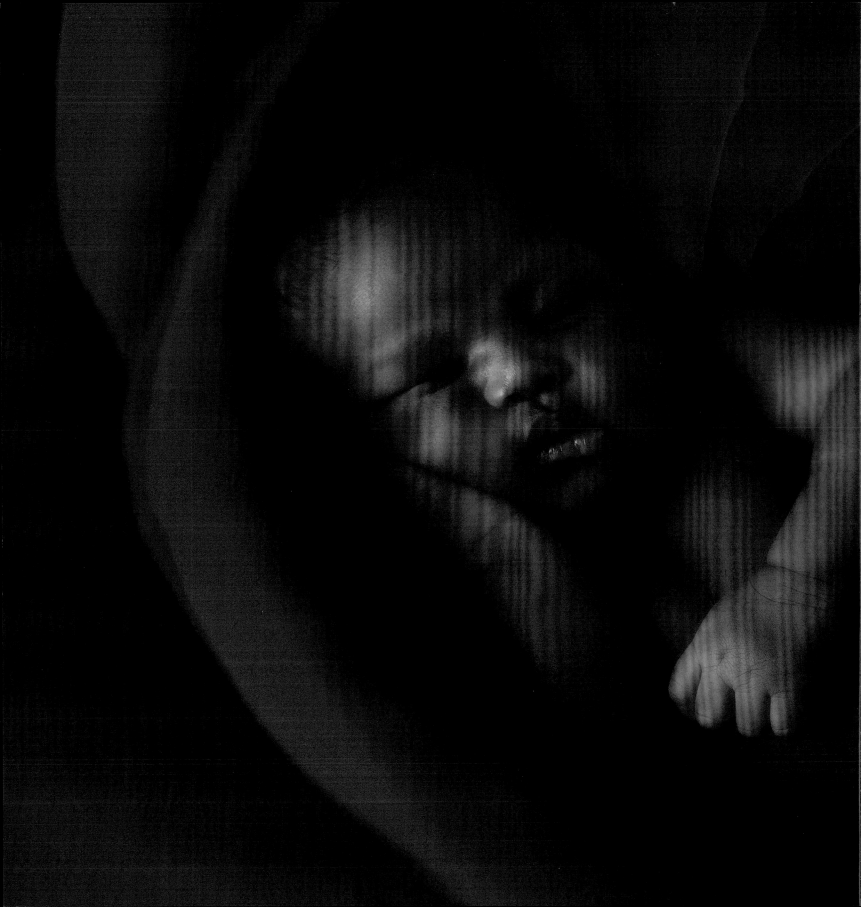

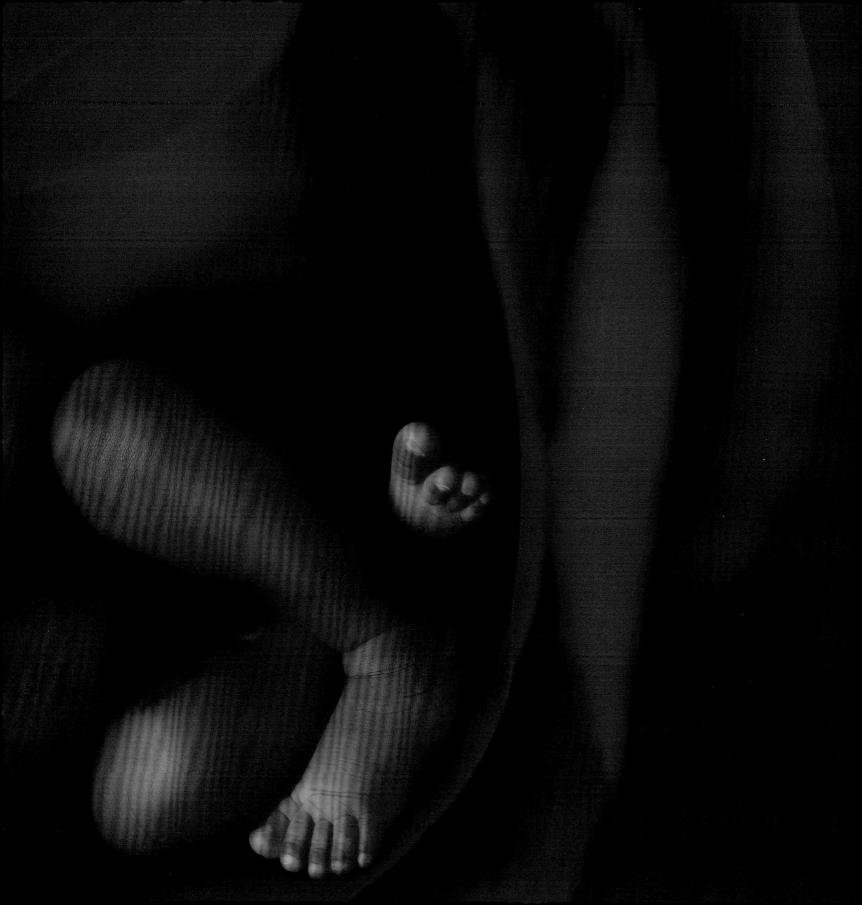

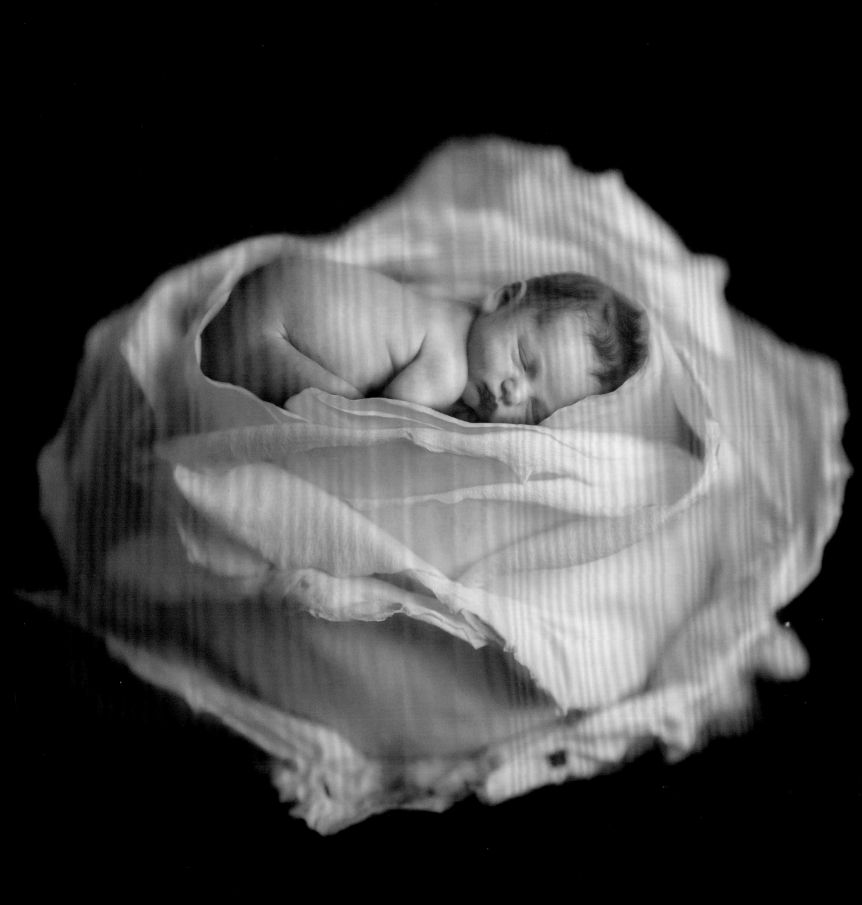

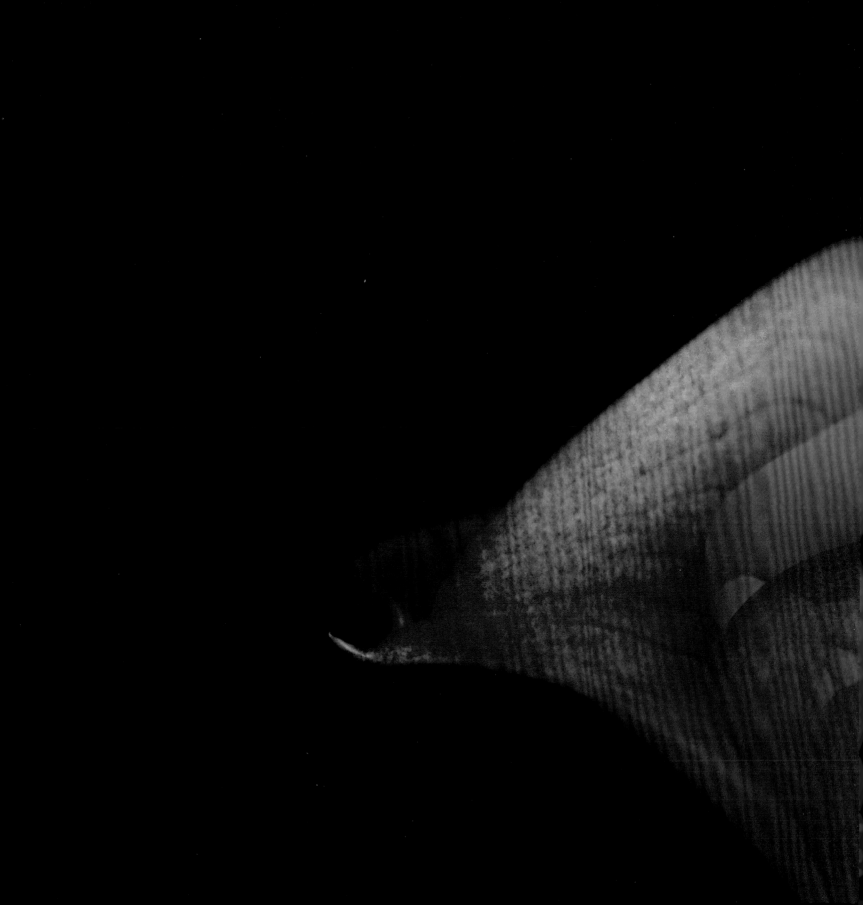

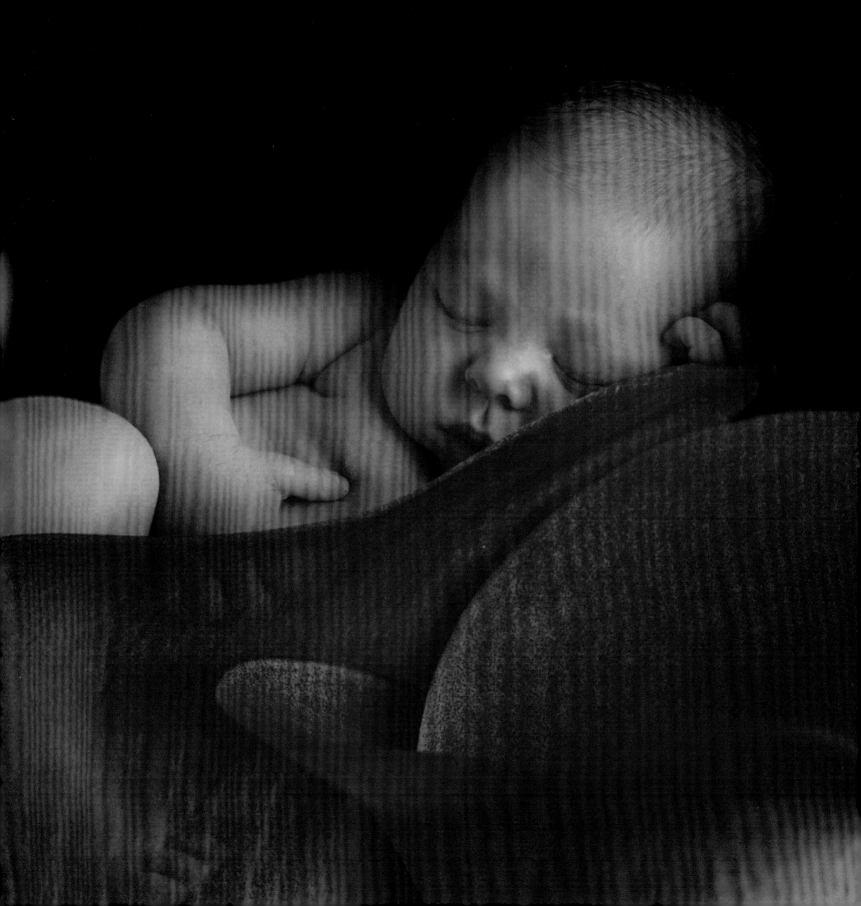

I have always felt that the

delicate, fragile, and yet fleeting

beauty of flowers

is so connected to the newborn.

The synergy between the two is perfect.

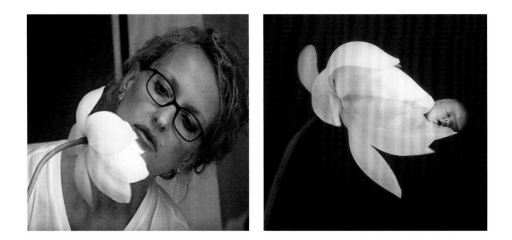

For as long as I can remember, throughout my long career as a photographer, I have loved to photograph flowers in my spare time.

It's the perfect antidote to a week spent working with tiny babies (my favorite pastime) when I have to be aware of every little nuance in the studio, not just with the babies, but also their parents, and the team of people I work with. As I explain in more depth in my autobiography, *A Labor of Love,* I am always very aware that a visit to my studio needs to be relaxing and enjoyable for all concerned, and my antennae are always on high alert on these occasions.

Photographing flowers, on the other hand, simply involves myself and a camera; I can work quietly on my own in a far more relaxing environment. Besides, flowers don't complain if I want to take a little more time to reflect. A few hours spent contemplating the beauty and complexity of a flower never fails to leave me feeling creatively refreshed and inspired.

Anne

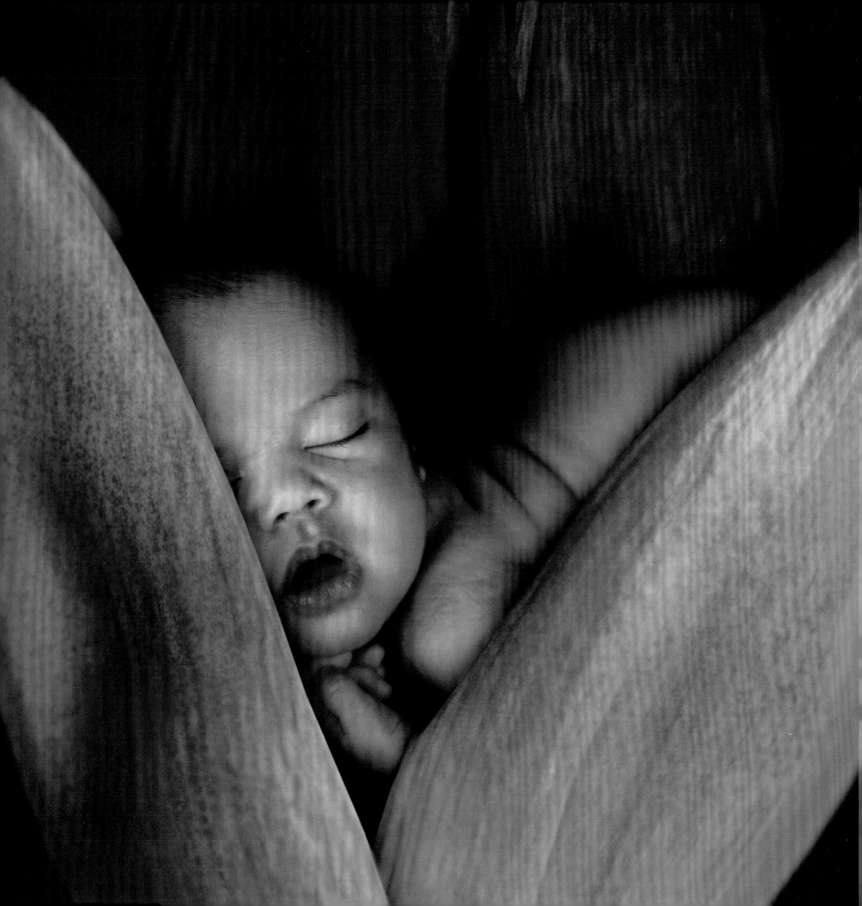

ANNE GEDDES ®

www.annegeddes.com

ISBN-13: 978-0-7407-7771-4
ISBN-10: 0-7407-7771-8
Library of Congress Control Number: 2008926309

Originated and produced by Anne Geddes Publishing
(a division of Hachette Livre NZ Ltd)
4 Whetu Place, Mairangi Bay, Auckland, New Zealand

This edition published in 2008 by Andrews McMeel Publishing, LLC,
an Andrews McMeel Universal company, 1130 Walnut Street,
Kansas City, Missouri 64106.

Designed by Lisa Waldren
Produced by Kel Geddes
Printed in China by 1010 Printing International Limited, Hong Kong

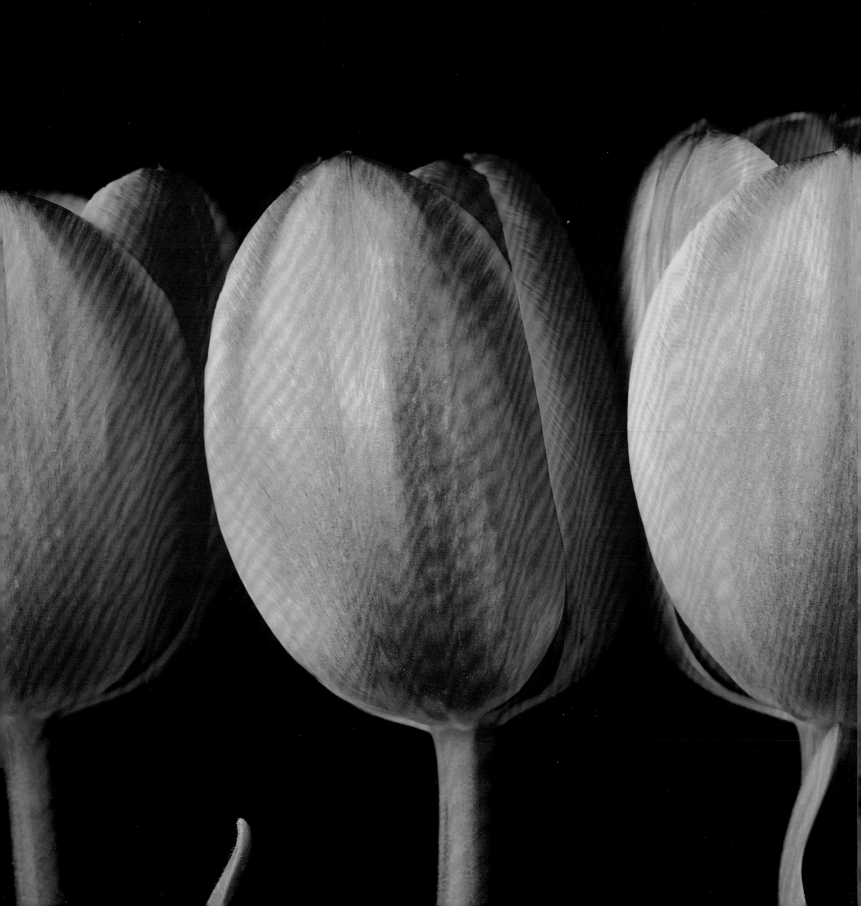